The Past at Work

The Past at Work

Anthony Burton

Photography by
Clive Coote

André Deutsch
British Broadcasting Corporation

This book is published to accompany
a series of BBC Television Programmes first broadcast
on BBC 2 in March 1980

Series producer: Michael Garrod

Published to accompany a series of programmes in consultation
with the BBC Continuing Education Advisory Council

Text © 1980 by Anthony Burton
Photographs © 1980 by the British Broadcasting Corporation
and André Deutsch Limited
First published 1980
Published by the British Broadcasting Corporation
35 Marylebone High Street, London W1M 4AA
and André Deutsch Limited
105 Great Russell Street, London WC1B 3LJ

Printed in England by W & J Mackay Limited, Chatham
This book is typeset in VIP Palatino, 10pt leaded 2pts

ISBN 0 233 97191 2 (André Deutsch)
ISBN 0 563 16386 0 (BBC)

62

(091)

Contents

7 *Introduction*

9 Chapter 1
Before the Revolution

27 Chapter 2
Steam and the Pit

49 Chapter 3
The New Iron Age

73 Chapter 4
Spindle and Shuttle

95 Chapter 5
To Make a Teacup

115 Chapter 6
The Venice of England

135 Chapter 7
Steam on the Move

155 Chapter 8
Railway Mania

171 *Gazetteer*

174 *Index*

Acknowledgements

Acknowledgement is due to the following for permission to reproduce photographs:

ANTHONY BROOME Middleton incline page 136; planeman page 136; Middleton Top page 137; 'hanger on' page 138; CAMBRIDGE UNIVERSITY COLLECTION Grimes Graves page 11; CARMARTHEN MUSEUM Roman gold pendant page 18; DUDLEY CANAL TRUST Dudley Canal Seal page 128; LOCAL STUDIES DEPARTMENT, CENTRAL LIBRARY, BIRMINGHAM Canal Act 1771 page 116; canal map page 121; MANSELL COLLECTION pump page 28; SCIENCE MUSEUM, LONDON millstones page 24; Newcomen engine page 29; Watt's single engine page 30; J.C.D. SMITH post mill carving page 26; EDWARD WINPENNY Bramhope Tunnel Memorial page 170.

Measurements

All measurements are given in imperial units, not because of any aversion to metrication, but simply because those are the units used by the engineers responsible for the original buildings and machines. George Stephenson may not have had any very sensible reason for selecting 4ft 8½ inches as the gauge for his railways – indeed there is very good reason to think he selected that measurement simply because it was the gauge at the colliery where he first began to work on railways. But, whatever the reason, it was 4ft 8½ inches that became the standard gauge – not 1.4353 metres!

Introduction

Ours is an industrial world, yet it is only quite recently that we have begun to take an interest in the remains of our industrial past. Britain was the first industrial nation, and is therefore uniquely rich in those remains. They represent the past of Everyman and speak to us more directly than any ruined castle or stately home can ever do. It was once considered to be at best a mark of mild eccentricity to take an interest in such sites: now, happily, that is no longer true. Tens of thousands of visitors enjoy looking at the buildings and machines of early industry. What I hope to do in this book is to show how some of these sites fit into the overall pattern of change. For it was in such places that the modern world was made, not by statesmen and philosophers, but by men, women and children with dirt on their hands. It was a past made up of the noise and clamour of machines, yet the remains are often touched with their own strange beauty. It is a world that more and more people are coming to appreciate as having a unique fascination.

The Past at Work was born out of a television series, so the number of sites that could be included was strictly limited. The producer, Michael Garrod, and I agreed upon one limitation straight away: all sites that we included had to be open to visitors. We hoped – and hope – that people would want to get up and see these places for themselves. The second restriction we imposed was more difficult, but eventually we decided that we ought to concentrate on the technological part of the story, and let the social implications appear where they arose naturally in the narrative. A third criterion was that we should only concern ourselves with those sites where buildings and machines could be seen in an appropriate setting, thus ruling out the older, conventional types of museum. Even so we were still left with an appalling task of selecting a few sites to cover eight major topics. This not only meant leaving out important sites – it meant leaving out whole industries! The book follows the same pattern as the series though I am well aware that every enthusiast will have his own list of sites which will almost inevitably be different from mine. In particular, I fear I shall be visited by the wrath of the Scots for omitting New Lanark, Bonawe and others, and can only beg mercy.

Anthony Burton

Before the Revolution

There is a great temptation when writing about 'The Industrial Revolution' to think of it as occupying a precise position in time, in the same way as the French Revolution or the Russian Revolution. 'The Industrial Revolution', declares a book facing me across my desk, '1760 to 1830'. Nobody believes that the world became industrialised by divine edict on 1 January, 1760, but looking through the list of events and inventions of the 1760s, it is not difficult to see that period as a starting point: 1760, Carron iron works founded; 1761, the first British canal opened; 1764, spinning jenny invented; 1767, iron rails made at Coalbrookdale; 1769, Arkwright builds the first successful cotton mill and Wedgwood is established at Etruria. So the list rolls on, a whole series of vital developments in just a few years. But these were not the seeds of industry, merely the flowering of a plant that had been many centuries in the growing. How far back do we have to go to find the beginnings of industry? That depends very much on what definition of industry we use.

First, then, a set of rules: industry, even at its simplest, implies the use of tools or machinery, resulting in some extension of what a man may achieve with his bare hands. Secondly, it involves more than one person: the potter working on his own is a craftsman; 20 specialist potters working as a team are an industrial unit. That implies another condition. The industrialist is making something not merely for his own use, but for a wider community – something the community as a whole thinks is so valuable that some members are prepared to till the ground, tend the herds or, in other words, work to produce enough extra food to enable the industrial worker to get on with his job. We can find all these conditions satisfied around 4000 years ago in the neolithic or stone age.

Britain around 2000 BC was thickly forested, and man had begun to abandon his old nomadic way of life, hunting wild animals and gathering plants for food. He was clearing spaces in the forest to grow crops and rear animals. To do that he needed axe and adze, but as iron making was still to come, the would-be farmer had to turn to the hardest material he could find that could be given a cutting edge. He turned to flint.

Flints are found in the chalk, which lies in a great band stretching from southern England up into East Anglia. Often it can be found at or near the surface: it was there waiting to be picked up. The neolithic man who did pick it up found it to be a very hard stone, but one with a very useful property. If he hit it with another stone, he could break off sharp-edged flakes which could be used as knives or scrapers. With practice he found he could shape the flint into axe or arrow head, a process which we know as 'knapping'. Then by rubbing and polishing he would end up with a smooth, thoroughly workmanlike and very hard-wearing implement.

Previous page
Entrance to an adit, Roman gold mines, Dolaucothi.

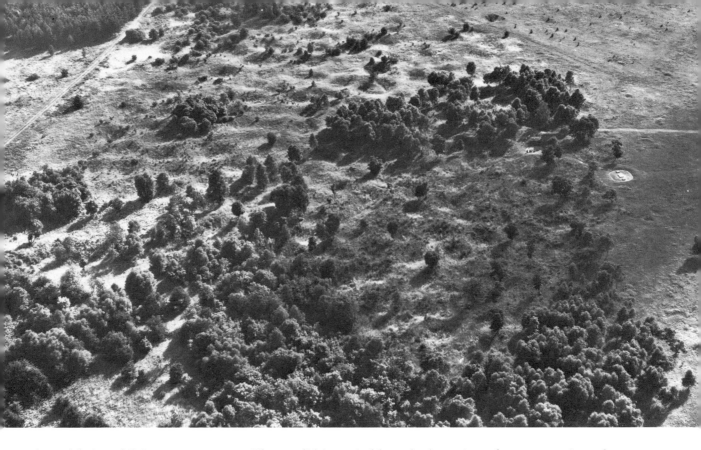

An aerial view of Grimes Graves, looking like a shell-scarred battlefield. Each of the craters represents a filled in, neolithic flint mine.

The neolithic period lasted a long time, from approximately 4000 to 2000 BC, and in that time men came to appreciate that some flints were superior to others. They were stronger and took a truer, sharper edge. Now if the settled communities could manage to produce more food than they needed for their own survival, they could use the surplus to barter for the superior flints. It would then be worthwhile for other men, living in the good flint regions, to devote more and more time to digging out and preparing the flints. In time, the flint miners would develop special skills and techniques, improving their efficiency to the point where it would be possible to concentrate entirely on this work. They would become an industrial unit; and that seems to be more or less what happened at Grimes Graves in Norfolk.

Grimes Graves covers an area of some 34 acres. Seen today, it is an area of scrubby chalkland, full of little dips and hollows. It is not easy to appreciate its significance, but seen from the air it takes on the appearance of a First World War battlefield, pitted with nearly 400 circular craters. These are the remains of a great flint mining complex, the filled-in pits from which the flints were removed. Presumably men first attacked the flint where it outcropped at the surface, and since it proved to be of excellent quality the veins were followed underground. In fact the site was not developed until the very end of the neolithic period, about 2000 BC, by which time metal in the form of bronze was already beginning to replace stone. It was already out of date, but the miners at Grimes Graves could at least draw on the experience of other workers. Their techniques were sophisticated and well organised.

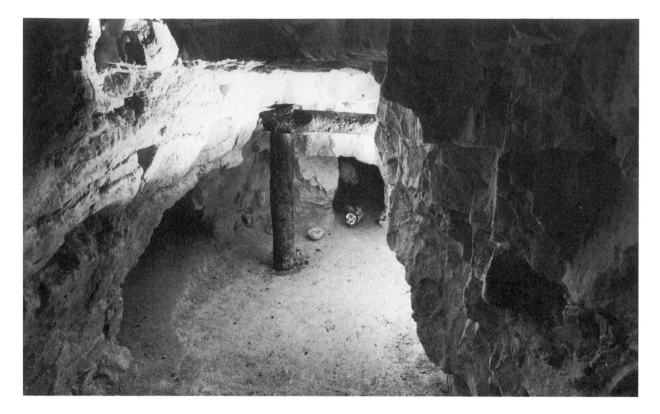

They discovered that the flint occurred in bands at different levels, with the best flint at the bottom. So a shaft had to be dug down deep enough to reach the floor stone – the flint to be worked – the deepest shaft being in the region of thirty-five feet. Recent work in one pit has suggested that it would have taken twenty men around three months to sink. Their tools were simple: flint axes, antlers for use as pickaxes, animal shoulder blades for shovels. They worked down in stages, leaving platforms to support a series of short ladders. Once the flint was reached, men began working out horizontally in a series of galleries, one man per gallery. They would crawl into the narrow passageways, passing flint and spoil out behind them to the main shaft for haulage to the surface. Beyond about four yards, this became impossible: the miner could not throw the waste out, and there was certainly no space in the galleries to turn round to push it out in front of him. So a second man had to come in behind the first to clear the spoil. By the time the gallery had reached about twelve yards, there were four of them spread out along the passageway and only one of them was actually producing any flint. At this point the work was simply abandoned. The miners worked as many galleries as they could from the foot of the shaft, then started all over again with a new shaft.

Part of the underground labyrinth of passages at Grimes Graves. The small bowl to the author's right is a simple lamp fashioned out of chalk.

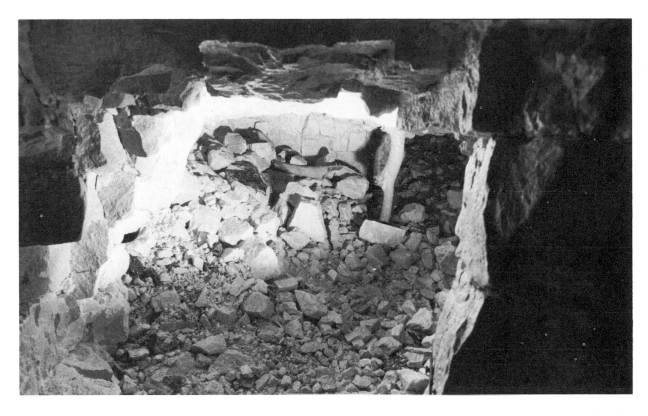

Part of the old flint mine that has remained undisturbed since neolithic times. The antler, propped between floor and roof, was once used as a pick axe.

Going down these shafts and galleries one is impressed by the skill of the workmen. They levered out the flint with their picks, leaving just enough support for safety, their work lit by simple lamps made out of chalk, shaped into bowls and filled with fat or oil. Occasionally they broke through into an old gallery which had already been exhausted and so abandoned that particular working, leaving the hole as a window through which we can view an ancient world. It is an eerie sensation to look through one of these small gaps at a scene that has remained unchanged for 4000 years, the worn-out tools left behind at the face, just as they were when the last miner left for another shaft. In pit 15, one of these windows reveals an antler propped between floor and roof, though it could never have borne any load. Perhaps it was left as a propitiatory offering to the kindly gods who had allowed man into their underground domain.

By the time a shaft was abandoned it could have yielded as much as 50 tons of flint. Up on the surface piles of broken flakes indicate where the flint was knapped. Current research suggests that these flints from Grimes Graves were in use over an immense area of Britain. How were they distributed? Did men from the mines go around with samples? Did communities send their representatives to the site to collect the flints? Were there special traders, middle men who acted

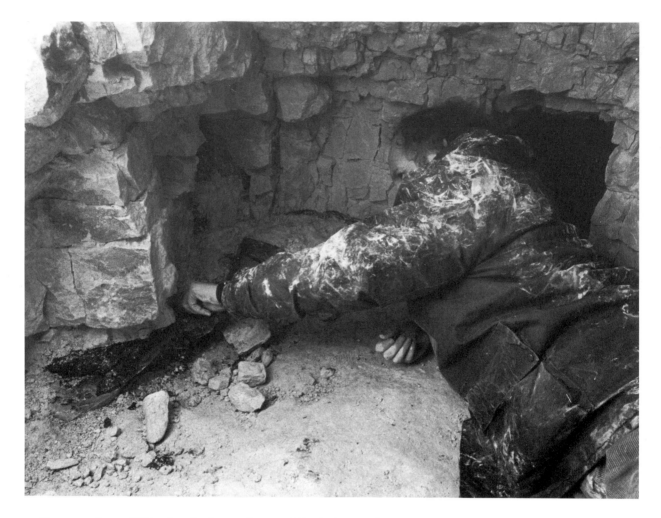

as flint merchants? We simply do not know. We do know that the 366 deep, galleried mines that have been identified represent a vast amount of labour carried out by teams of skilled specialists. All the rules for a definition of industry are satisfied. New research may push our industrial past back even further, but we can at least say with confidence that it has been with us for 4000 years.

Industrial progress in Britain was slow. The bronze age lasted until about the fourth or fifth century BC, when iron was introduced. Then there was a sudden, violent jerk forwards. The Romans came, bringing with them a new technology. We see their mark most clearly in civil engineering, in towns and roads, irrigation and ports. These were, in a sense, incidentals. The Romans did not leave the warmth of the Mediterranean for these chilly, damp isles in order to bring civilisation to a primitive people. They came to exploit the mineral wealth of the country. The lure was iron, lead, tin, copper – and gold.

The black band at floor level is the flint that was worked. The opening in the chalk behind the author's shoulder leads through to the old working shown on page 13.

Part of the opencast gold mine at Dolaucothi. In the background the deep cleft leads to underground workings.

Just outside the village of Pumpsaint in Dyfed is the site of the Roman gold mines of Dolaucothi. The Romans finally subjugated Wales around AD 75 and established a fort beside the River Cothi, on the site of the present village. Then they set to work extracting the gold. Much of the actual labour was done by local men under Roman supervision and under Roman rules. These rules included a regulation that insisted on baths for miners, though such a 'luxury' was not again available to British miners as a right until the present century.

At first sight, the mines at Dolaucothi are not so very different from the neolithic mines at Grimes Graves. Investigation, however, soon reveals crucial differences. The Romans introduced machinery and a source of power greater than that of a man's arms. We are about to move a good way up the technological ladder.

Looked at from a distance the site is rather like a giant gruyère cheese with a bite out of it. The cheese is the hillside of Allt

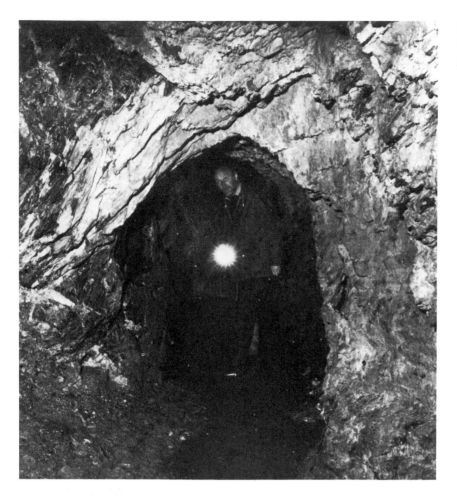

Inside one of the typically horseshoe-shaped adits at the gold mine.

Cwmhenog, the bite is a huge opencast working and the holes are the many tunnels dug deep into the hillside. One thing soon becomes apparent: these tunnels and adits are far larger than their counterparts at Grimes Graves. There men crawled; here they can walk upright. No space is wasted. Many of the adits are horseshoe shaped; narrow at the bottom, widening out at shoulder height, so that the miners could carry a load, and making an arch overhead. These miners had many advantages over their neolithic forebears. For a start, they had iron tools, which was just as well since they had to cope with hard rock instead of soft chalk. And if these proved too weak for the job in hand, they could use fire setting. Rock was heated until it was red hot, then cold water was thrown on it, the sudden contraction causing the rock to split. It was an effective enough technique, but standing in one of those narrow adits one can imagine the atmosphere heavy with smoke and steam and appreciate why the technique was used as little as possible.

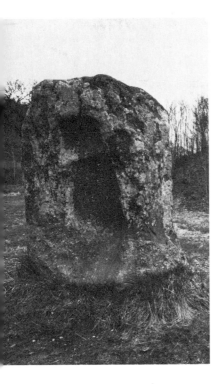

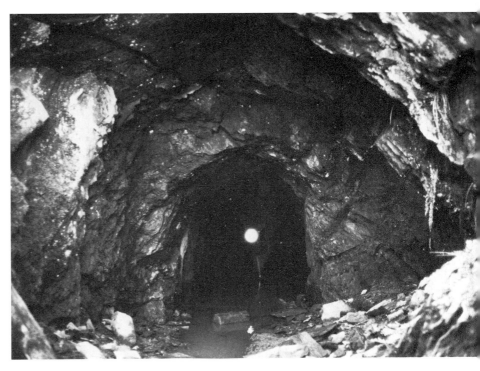

Above
This stone still shows the scars inflicted by Roman miners breaking rocks against it to expose the gold ore within them.

Above right
A drainage adit at the foot of the main opencast, still trickling water from the abandoned mines.

The miners faced another problem: water flooding into the workings. This was partially solved by digging a shaft down below the water level and into a drainage adit. The entrance to the main adit, with its steadily flowing stream of water, can be seen at the foot of the opencast. Water is the enemy of all miners, but it can also be put to good use, and nowhere in the ancient world were there hydraulic engineers to match those from Rome. At Dolaucothi they used water power for a whole variety of purposes, the most spectacular process being that of 'hushing'. A powerful jet or stream of water was directed down the hillside, sweeping away the topsoil and loose rubble to expose the valuable ore. Water was also used for washing the ore and for separating the gold particles from the waste material. The mixture was washed over a series of little rock ledges, in which the heavy gold was trapped while the waste was carried away. Some water might even have been used to work machinery. It was all very effective, but the Romans had one major problem to overcome: they had to get the water to the site in the first place. The rivers Cothi and Annell are close at hand, but the mine site is high above them. So the Romans simply traced the rivers back until they reached a point higher than the workings and constructed aqueducts to take the water to reservoirs above the mine. Those aqueducts were major works, for to reach that higher point on the River Cothi they had to go back a full seven miles.

The value of this new source of power is obvious from the efforts made to bring it to the site. It is no mean task to build aqueducts over such hilly ground, and considerable surveying skill had to be used to hold the level. There are few steep sections on these aqueducts, and those are limited to short cuts through the rock near the mine itself. The reservoirs are equally impressive, the largest containing the water behind banks eighteen yards thick. They have been estimated to hold a quarter of a million gallons, so that a huge flow of water would have been possible at the workings.

It was well within the capability of the Romans to put the water to another use. They could have used it to turn a water wheel, for such

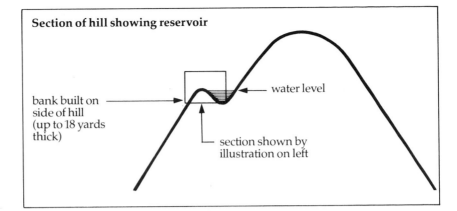

Section of hill showing reservoir

bank built on side of hill (up to 18 yards thick)

water level

section shown by illustration on left

Left

Remains of one of the reservoirs at the top of the hill. The high containing wall is on the left. Water was released down the slope of the hill to wash away the topsoil.

Below left

A Roman gold pendant and chain found at Dolaucothi, now in Carmarthen Museum.

devices were already known in the ancient world. The earliest type found in Britain is the horizontal or Norse wheel, in which paddles are fixed to a vertical shaft set directly into a fast flowing stream. This type of wheel originated in Scandinavia, and examples of it can still be seen in the Orkneys, where they were used to turn grain mills. They are far less efficient than the familiar vertical or Vitruvian wheel: here paddles are mounted on a horizontal shaft and turned either by water hitting the paddles on the lower part of the wheel, the under-shot wheel (see page 78), or, more efficiently, by water falling into buckets mounted on the wheel rim, the overshot wheel (see page 65). The Vitruvian wheel was, in fact, invented by the Romans, but they were sparing in its use. The authorities preferred to use men rather than machines – one of the rare occasions in the history of technology when full employment was preferred to technical advance.

At Dolaucothi a machine was in use that might be called an over-shot wheel in reverse. It was a drainage wheel and instead of water being poured in at the top and falling out of the bottom, the water was scooped up at the bottom and fell out into a drainage channel at the top. The power was supplied by men treading for hours on end on the edge of the wheel. The parts of this wheel that were found on the site are preserved in the National Museum of Wales.

Water power and the water wheel were to be a major force in technical development right through the Middle Ages and on into the early years of the industrial revolution. It was a most versatile power source that could be adapted to a whole range of tasks, from turning the grindstones of a corn mill to working the hammers of a forge. We shall be meeting it again in many of the other industrial sites we shall be visiting.

Dolaucothi shows man's adaptation of water power for his own use. There is one other natural source of power that man has employed for a very long time: the wind. We do not know who first discovered that cloth held up to the wind would help to move a boat across the water, but we do know that as early as 2500 BC the Egyptians had sailing boats that could take to sea. Wind power has played a vital role in transport until modern times. The idea of using the same power to work machinery was slower to develop.

The windmill was unknown to the Romans, though Hero of Alexandria, writing in the first century AD, described a little windmill which was used to work a piston which, in turn, blew air to organ pipes. This was merely a toy and nothing more was heard until a report came down of a Persian engineer building a windmill for the Caliph in the seventh century, and by the tenth century, a visitor to Persia was able to declare that there was nowhere on earth where man made better use of wind power. All early development was, in fact, confined to the Middle East, but the mills used there were all of the horizontal type, with rotating vanes attached to a vertical post. This method was never used in Northern Europe, where the familiar windmill seems to have developed quite independently.

The earliest record of a windmill in Europe dates from the twelfth century, while in Britain a drawing of a windmill can be seen in a psalter of 1270. Remarkably enough, one can still see windmills of just such a design, unchanged in all their essential features, at work in Britain today. One of these is preserved at the Avoncroft Museum of Buildings, a last refuge for threatened buildings. Obviously, everyone would prefer to see a historic building left *in situ* but, alas, in a changing world this is not always possible. When demolition is imminent, Avoncroft step in, carefully dismantle the whole structure and re-erect it on a large open-air site. This particular windmill once stood at Danzey Green, where it was used to grind corn for the people of Tanworth in Arden. It is by no means the oldest mill of its type in the country – that honour belongs to Bourn mill near Cambridge – but it has the one great advantage that it is in working order. Corn can be, and still is, ground here.

Although it was actually built around 1800 the construction method is still that of the medieval mill. The first essential for any windmill is that the sails can be turned into the wind. The simplest design is the one we find here, the post mill, which is simply a wooden box with sails attached, balanced on a central post. This is not immediately obvious from the outside because the central support is hidden behind a brick roundhouse, which protects the underframe and makes a useful storage space. Once inside, however, all is clear. The massive centre post rests on crossed timber beams, known as the cross tree, which, in turn, rest on brick piers. The structure is further supported by quarter bars, timbers running up from the ends of the cross tree to the post. The whole of the rest of the mill is balanced on top of the post. We tend to think of windmills as rather quaint and old-fashioned, so that it requires something of an act of imagination to see them as daring innovations. Yet that is what they were. Just consider the craftsmanship of the early carpenters and millwrights who had to build a structure strong enough to withstand the busy movement of sails and machinery, yet so perfectly balanced that it could be smoothly turned by one man. It is rather like watching

The base of the Danzey Green windmill. The floor of the main mill structure – the buck – is supported on the central post. The post itself rests on the cross tree of timbers mounted on bricks.

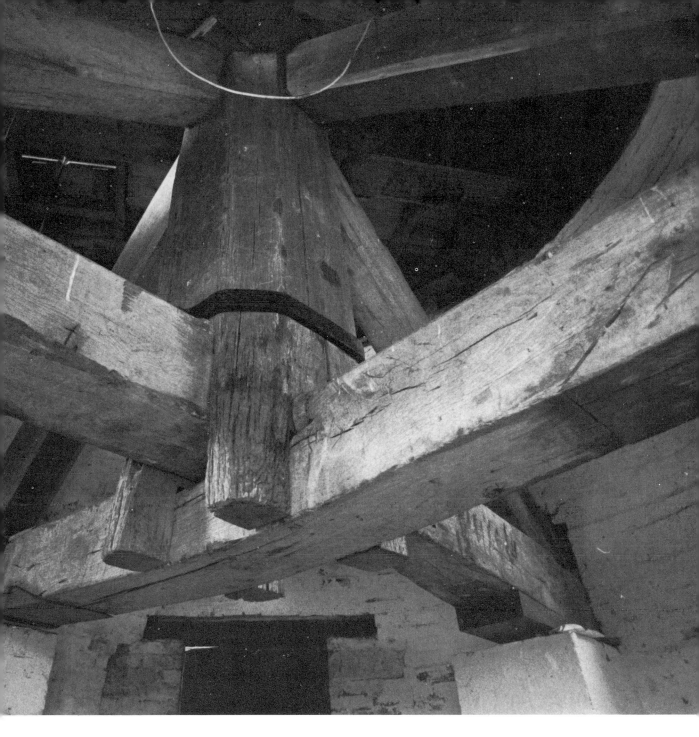

a balancing act in a circus: it looks simple enough when done by experts, but where would the rest of us begin!

Stepping outside again you can see a ladder reaching down from the main body of the mill and a long timber sticking through it and down to the ground. When the miller wants to move his mill, he hitches up the end of the steps using a pulley, grabs hold of the long timber or tail pole and bodily heaves the whole thing round. At Danzey Green, the less energetic could use a winch instead.

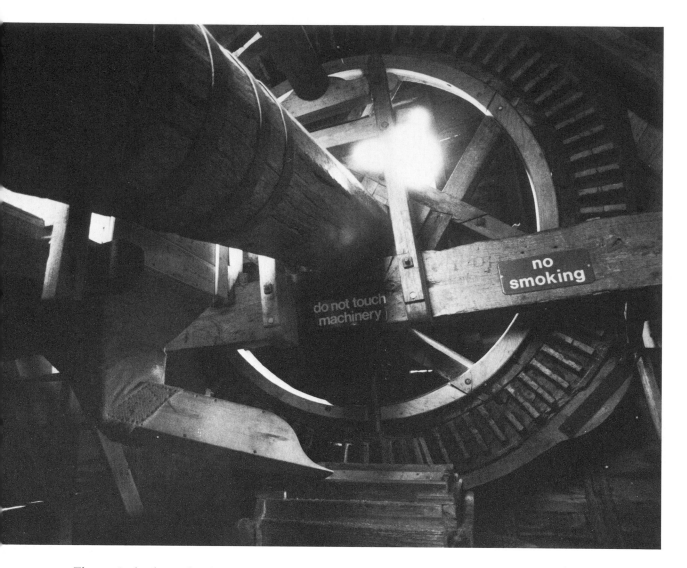

The main body, or buck, is a timber frame covered with horizontal weather boarding. Early mills had simple pitched roofs, but later mills have curved tops, providing better clearance for the machinery inside. At the top of the buck is the wind shaft with its four sails. Much of the miller's language is borrowed from the sea: he sails the mill and it, like a ship, is always a lady. The sails are not quite what one would find in a medieval mill. Two are common sails, spread with canvas, much like the sails of a boat, and these too can be reefed in a high wind. The other pair of sails are of a more modern design, adjusted for the wind by means of spring-operated shutters. Trimming the sails was very important. Too much sail in a high wind could tear the mill to pieces or cause the machinery to move so fast

The wind shaft which carries the windmill's sails. All the machinery is moved by gearing from this turning shaft.

22

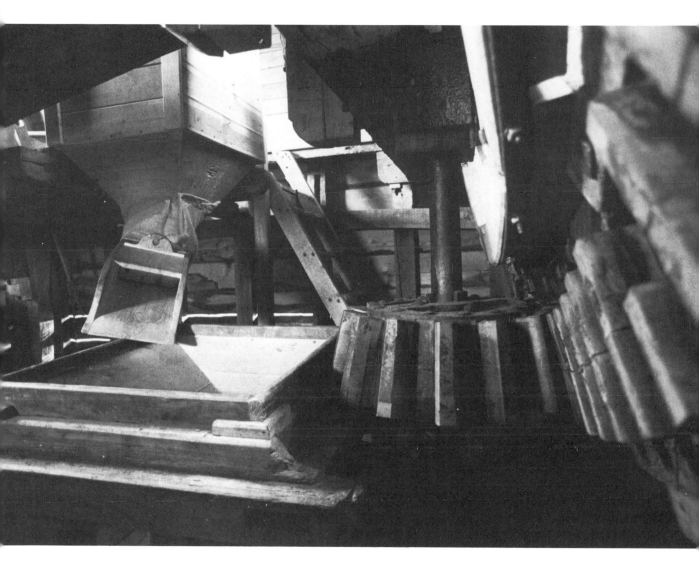

Grain falls down the shute to the enclosed millstones which are turned by the wooden gearing.

that friction caused the building to catch fire. The miller needed to keep a close eye on the weather.

Inside the buck is the machinery that turns grain into flour. Starting at the top of the building, the wind shaft carries a large toothed wheel, the brake wheel. The wooden brakes can be seen close to the outer rim. They can be operated from outside, which is a great help to the miller when he sets sail at the start of a day's work. He can allow the sails to move in a series of quarter turns for easy adjustment from the ground. The wooden teeth of the brake wheel engage with the teeth of a smaller wheel, the wallower, set at right angles to it. This enables the movement of the sails in the vertical plane to be converted into the movement of the grindstones in the horizontal. These stones

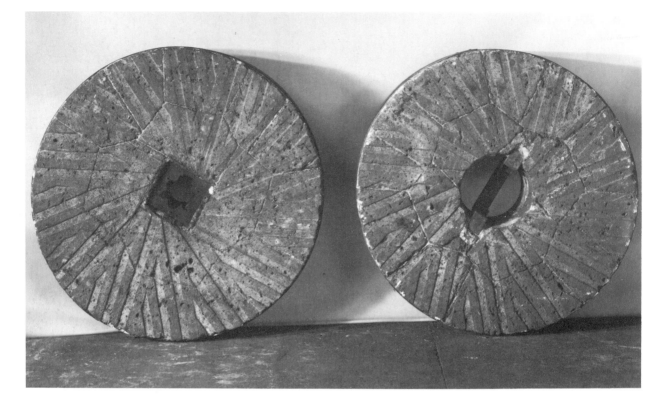

are at the centre of the whole process. The upper stone, the runner, moves over the fixed bed stone or lyger. This might seem to be the simple part: one stone moves over another and the grain is crushed. It is, in fact, a lot more complex than that. First the stones have to be 'dressed', cut with an intricate pattern of grooves. As the runner moves, the grain is sliced by these crossing grooves and eventually falls through a hole at the edge of the stones. Stone dressing follows designs that go right back to the Romans, and in a busy mill dressing might have to be repeated every two or three weeks in order to keep the edges sharp. Stones also come in a variety of different materials, and at Danzey Green they have some of the finest, French burrs. These are pieced together from a special quartz only available from a quarry near Paris.

The stones have to be carefully levelled and they are enclosed in a wooden tun ready to receive grain. The sacks of corn are pulled up to the top of the mill by a hoist turned by the windshaft and the grain is fed into a hopper from which it is shaken down onto the stones. A metal fork revolves with the runner stone and as it turns it hits the hopper with a steady clak-clak that is one of the characteristic sounds of a working mill. All day long the metal tongue clattered on and the male chauvinist millers christened it 'the damsel'.

A pair of millstones showing the elaborate system of grooves cut by the stone dresser.

Ground corn drops down into the bin from the millstones on the floor above.

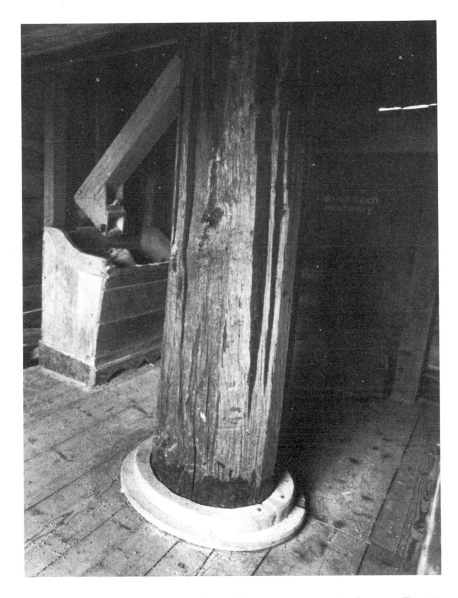

The flour that came from the mill was not yet ready for use. First it had to be sifted. This was done by hand using a sieve known as a 'temse'. Shake it hard enough, and the sieve could get quite warm; neglect your duty and the miller might call out: 'You'll never set the temse on fire.' And that is the origin of a saying that has nothing to do with a river flowing through London. Later the process was mechanised when a simple machine called a bolter was introduced. In essence, it is a cylindrical frame covered by a cloth and inclined downwards. The flour drops in and the bolter turns, brushing up against bars as it goes. The fine flour is gradually knocked out through the bolter cloth.

This is the basic mill. There are a few extra refinements, such as the governor. In variable winds, the speed of the mill can vary, and there is a tendency for the runner stone to lift at high speeds. To avoid constant adjustments of the sails, the centrifugal governor was introduced. Two metal balls are fastened to the turning shaft. As the shaft goes faster, the balls move away from the shaft, lifting one end of a lever. The other end presses on the stones, keeping them close together.

Later post mills were improved by the use of the fan tail, a sort of secondary windmill mounted on the tail pole. The pole itself was given a runner which moved on a circular track. As the wind changed, so the fan tail reacted, dragging the mill round to the correct position. Other types of mill were built to supersede the post mill. In tower mills and smock mills, the main structure is solid and unmovable and the sails are fastened to a rotating cap. The windmill had a long and honourable career, but although it found some uses besides grinding corn, such as powering drainage pumps, it never showed the versatility of the water mill. The water wheel was less dependent on the vagaries of the weather. Unlike the wind, water can be stored up and released at a controlled rate. One should not, however, underestimate the importance of the windmill in the history of industry. The miller himself has a somewhat ambiguous role. The peasant bringing his sack of grain to the mill had no means of estimating how much flour he could expect out at the other end, so he had to rely on the honesty of the miller. While English literature has its share of merry millers, it also has Chaucer's less admirable character:

> 'He was a thief as well of corn and meal
> And sly at that; his habit was to steal.'

The millwright, who built the mill, had a very different part to play. He was the man who could handle gears, balance machinery and set the works in motion. As the process of industrialisation began to gather speed, the millwright's importance increased. It was from his ranks that many of the early engineers were to emerge.

Well before the beginning of the eighteenth century, Britain had many of the skills necessary for industrialisation. There was power available from wind and water. There were men used to working with machines. There was mineral wealth under the ground and many centuries of experience at mining to help men extract it. There was, however, one major obstacle to confront before that mineral wealth could be fully exploited, and in surmounting it man came up with one of the most important inventions of the industrial age.

A post mill carved on a bench end at Bishops Lydeard, Somerset.

Steam and the Pit

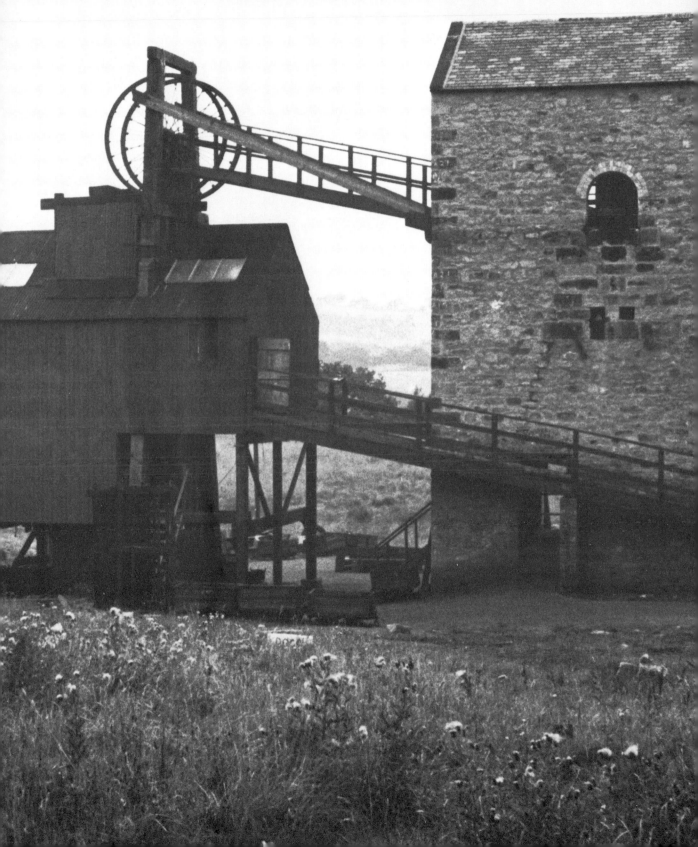

Coal was essential to the industrial revolution. It was fuel for a whole range of industrial processes; and it was fuel for the new generation of industrial workers. Those who left the country for the town left behind their supplies of firewood, gathered from copse and hedgerow, so the towns were marked by the smoke of countless coal fires.

There is no shortage of coal beneath the soil of Britain, but to reach it miners must first subdue one powerful adversary – water. Virtually all mines have water in them to some extent. At Dolaucothi, the Romans dug drainage adits deep into the hillside and set men to work trudging on the drainage wheel. Later pumps were introduced, powered by water wheels. This all worked well enough for shallow mines, but by the end of the seventeenth century the stocks of shallow coal were running low. Men had to go very deep for the coal, deeper than any adit could be driven and deeper than the old pumps could work. A new method of drainage was urgently needed, and in finding an answer to that problem, engineers opened up a new age of mining, and, at the same time, produced a new source of power.

Throughout the seventeenth century, the London patent office was kept busy with a deluge of inventors, each with his own remedy for the deluges in the mines. Among them was Captain Thomas Savery. His patent of 1693 was for a machine he named 'The Miner's Friend', or a machine for raising water by 'the impellant force of fire'. It was worked by condensing steam in a large vessel, creating a partial vacuum. Water then rose in the vessel to fill that vacuum, and was then pushed even higher by high-pressure steam. As it pushed up water rather than pulled it, the machine had to be set at the foot of the shaft instead of the top. Given the state of technology at the time, the miners must have viewed the sight of a high-pressure boiler at the bottom of the pit as a somewhat alarming friend. Savery's engine had a short life, for it was soon superseded by another pumping engine that used the condensation of steam in a very different way.

The second steam pump was the work of a Dartmouth man, Thomas Newcomen. He was a supplier of iron tools to the tin miners of Devon and Cornwall, so he was very familiar with the problems caused by inundations. His idea was simple, his engine massive and crude enough to be well within the boundaries set by the technology of the day.. Few Newcomen engines survive, but one has been rescued and erected in Newcomen's home town where it occupies a somewhat unlikely site in the municipal gardens with an ornate bandstand as companion. It began life somewhere around 1720 at the Griff colliery in Warwickshire and was later moved to Hawkesbury Junction, where the Coventry and Oxford Canals meet. The engine house still stands at the junction and, at the time of writing, great efforts are being made to ensure that it is preserved. However, the survival of the engine is assured – a memorial to the man who could reasonably be named as the only true begetter of the steam engine.

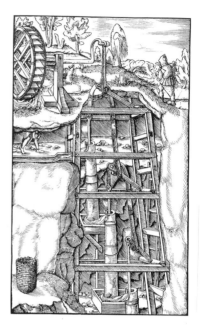

Above
A water-powered pump for mine drainage from Agricola's De Re Metallica, *1556.*

Right
The first Newcomen atmospheric engine, erected near Dudley Castle in 1712.

Previous page
Pit-head scene, Beamish.

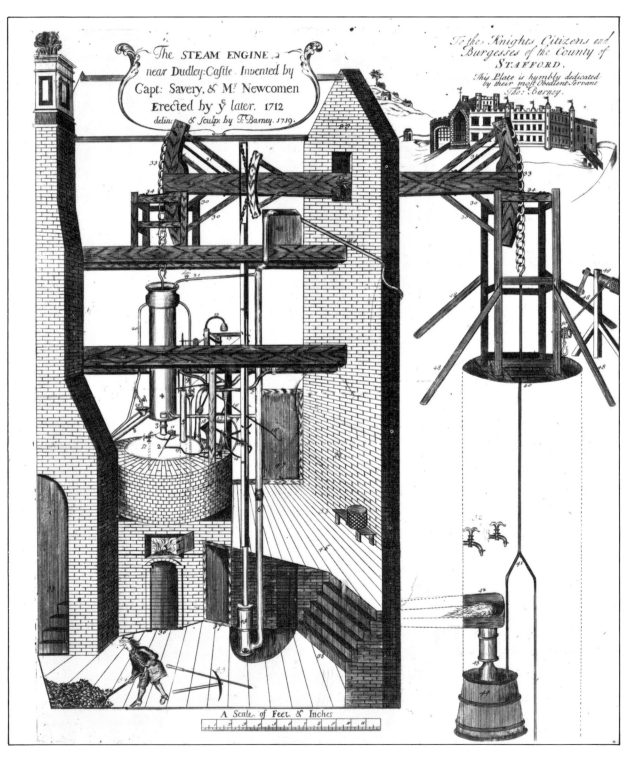

The STEAM ENGINE near Dudley-Castle. Invented by Capt: Savery, & Mr. Newcomen Erected by ye later. 1712 delin: & sculp: by T: Barney. 1719.

To the Knights Citizens and Burgesses of the County of STAFFORD. This Plate is humbly dedicated by their most Obedient Servant Tho: Barney

A Scale of Feet & Inches

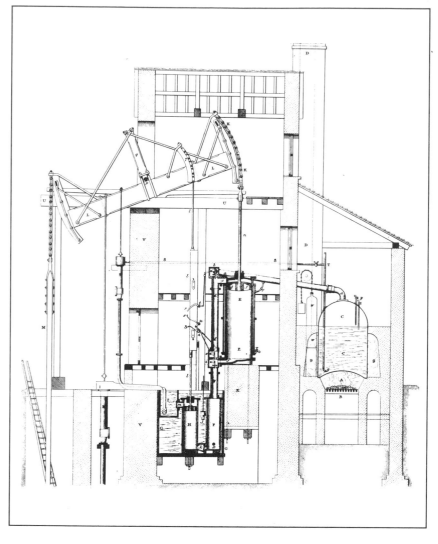

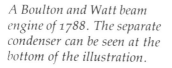

A Boulton and Watt beam engine of 1788. The separate condenser can be seen at the bottom of the illustration.

The actual job of pumping is performed by heavy rods passing down the shaft, working a plunger or suction pump. If the rods move rhythmically up and down in the shaft, then water can be brought to the surface. The weight of the rods themselves would carry them down: what Newcomen provided was a machine to lift them up again. The rods were hung from one end of a massive beam, pivoted at its centre. From the other end of the beam hung a piston that passed into a cylinder. Steam was passed into the cylinder below the piston, then condensed by being sprayed with cold water: the same idea as that used by Savery. In Newcomen's engine, however, no water passed inside. Instead, air pressure pushed down on the top of the piston forcing it down into the cylinder. As the piston went down, so the pump rods were lifted up. The pressure equalised, down went the rods again and the whole cycle restarted. The first Newcomen engine began work at Dudley Castle in 1712, and soon the giant engines could be seen nodding their great heads over pit shafts throughout the land.

The Newcomen atmospheric engine was a success, but an expensive one. For more than half a century, it dominated mine drainage, but if we look at it in terms of efficiency it rates very badly. The actual energy was supplied by burning coal to raise steam, and only a miserly 1 per cent of that energy went into the actual work of lifting water. You had to burn a great deal of coal to achieve very little. The next major improvement was to prove of vital importance.

In 1763, the University of Glasgow had a model Newcomen engine which, to their embarrassment, refused to work, so they sent it along to the University instrument maker for repair. He soon realised that the trouble lay with the massive steam consumption and he thought up a solution. The man's name was James Watt, his solution the separate condenser. The engine, he realised, could never be efficient so long as hot steam was wasted in warming the cold cylinder after every stroke. He added a separate vessel into which the steam could be drawn for condensation. This new condenser could be kept permanently cold, but the cylinder would still lose heat out of the open top. So he closed the cylinder off. Now, of course, air pressure could no longer act on the piston, and Watt had to use steam pressure instead. The atmospheric engine had become the steam engine proper. Watt was fortunate in that he found a partner who appreciated the potential of his invention and had the resources to exploit it. This was the Birmingham manufacturer, Matthew Boulton, and the firm of Boulton and Watt became one of the most famous in the whole history of technology. Boulton himself once explained his success to George III in these few words: 'I sell, sire, what all the world desires – power.' And indeed they monopolised the manufacture of steam engines right up to the beginning of the nineteenth century, when their patent expired.

Though there are no longer any Newcomen engines at work on their original sites, Boulton and Watt engines have survived. One of these, built in 1812, is the oldest steam engine still able to perform the job it was installed to do. It is a magnificent tribute to the strength of these machines that an engine that started work when Napoleon was beginning the long trek back from Moscow can still be seen pumping away with all its old strength. The engine is not, in fact, at a colliery site but the job is essentially the same – lifting water, in this case up from a lake to supply the summit level of the Kennet and Avon Canal. So, although the atmosphere of this quiet and beautiful countryside may have little in common with a bustling colliery, Crofton pumping station is still the best place to go to see an old beam engine at work.

There is not much about the outside of Crofton to cause excitement; just a tall brick building with a lean-to extension and a high chimney stack. But the building is more than just a cover to keep off the rain. The beam engine is a powerful creature, and the engine house has to act as support and anchor for its slow, steady movements.

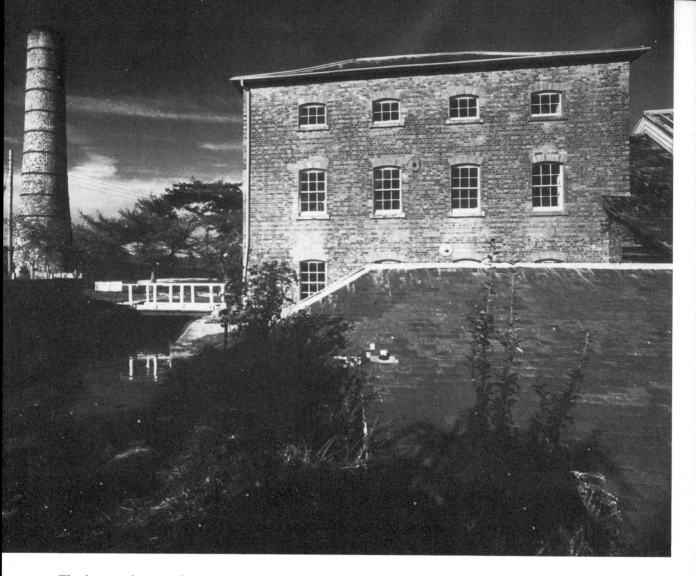

The lean-to houses the boilers, while the tall chimney ensures a good draught to the fires – not as good as it should be, since someone misguidedly shortened the chimney.

Main interest naturally centres on the engine house, and visitors who want to make sense of the whole process should go straight up to the second floor, the very top of the building. Here are the beams of the two engines, each 29 feet long and weighing around six tons. Originally the pistons of beam engines were hung from the ends of the beams by chains. If you watch the movement of the beam, you will see that the end follows a curved path. A rigid piston fitted to it would swing like a pendulum instead of moving straight up and down. The flexible linkage kept the pendulum vertical, but it meant that the piston could only pull down and not push up. Watt solved this problem with a device of which he was inordinately proud. It was his parallel linkage which, as the name implies, consists of a moveable parallelogram of rods, from one corner of which the piston is suspended. He had every right to be proud. It is a most elegant device, and hypnotic to watch in motion.

Above
Crofton pumping station on the Kennet and Avon Canal.

Right
Danzey Green windmill, re-erected at the Avoncroft Museum of Buildings.

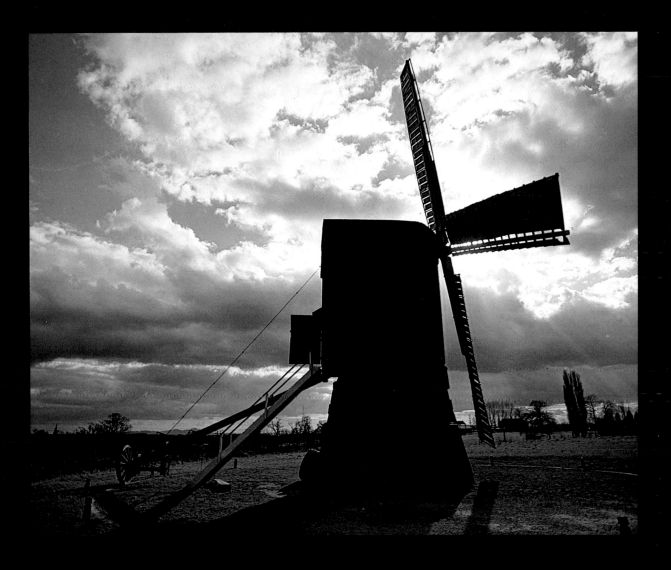

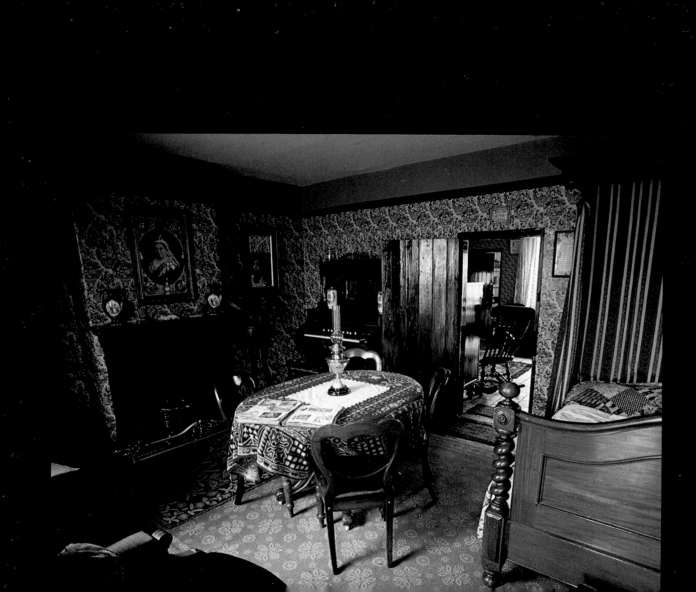

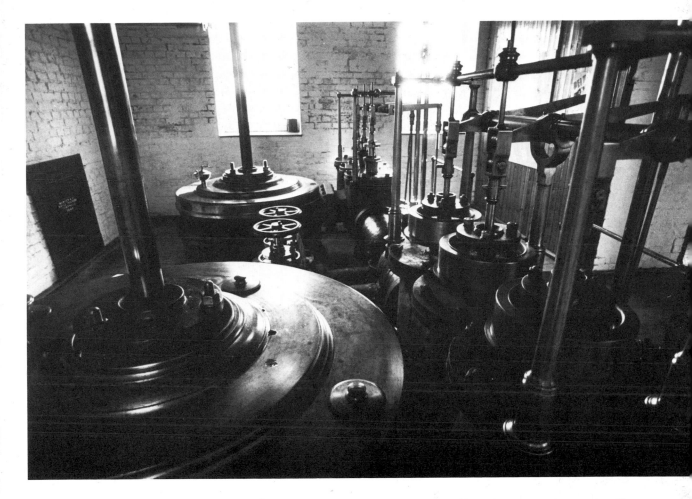

Above
The tops of the cylinders of the two beam engines at Crofton.

Left
Miner's cottage at Beamish. The living room had to double as the main bedroom.

On the next floor down are the cylinders. When the engine first lumbers into life, the valves that allow steam into and out of the cylinder have to be operated by hand, but once under way they are worked automatically. Back on the ground floor you can see down into the pit where the steam is condensed. It is tempting when watching such engines at work after 150 years of use to praise the superiority of the old engines over our modern machinery with its comparatively short working life. Certainly there is beautiful craftsmanship to admire at Crofton, but the longevity is not attributable to finely-tuned engineering – rather the contrary. The beam engine survives because of its crudity, not its refinement. Accurate piston fit, for example, is not essential: where we think in thousandths of an inch, early engineers thought in tenths. Indeed it was only with the invention of a boring machine by John Wilkinson in 1774 that anything like an accurate fit between piston and cylinder became possible. Movement is slow, tolerances are large.

35

To understand just how rough and ready the early steam engines are, you only have to look through a Boulton and Watt instruction manual. These engines were sold rather in the way that a modern Do It Yourself merchant would sell you a kitchen cabinet. You got a lot of pieces, and a book telling you how to put them together. One thing soon becomes clear: you were expected to give a little assistance in the business of ensuring a tight fit of the piston. The seal was made good by making a gasket from rope covered with tallow and beaten into place by a sledge hammer. 'The packing of the piston,' declares the manual, 'should be beat solid, but not too hard, otherwise it will create so great a friction as to hinder the easy going of the engine. In time, given a good greasing, the cylinder grows smooth.' Such an engine was clearly no delicate creature.

The Crofton engines still pump water and it is when they are at work that you see their immense power. Working together they can shift a quarter of a million gallons an hour. Rough and ready they might be in one sense, but to see these ageing giants at work is pure delight. We might seem to have come a long way from mining, but it was the availability of an engine that could shift millions of gallons of water each and every working day that enabled the miners to develop the new, deep pits. The engines became features of every pit head. They were soon adapted for other uses besides pumping. At one time men and coal had to be hauled to the surface by the horse gin, a device in which a horse walking around a circular track turned a drum around which a rope was wound which then led to the shaft. Now a small adaptation was all that was necessary to allow the beam pump to turn a winding drum instead.

The steam engine is all but finished at British collieries, its place taken by the electric motor. Only on those collieries where work has ceased can we still see the steam engines as they were a century ago. In Cornwall, where the old tin and copper mining industry is virtually extinct, the engine houses remain in profusion to give some idea of the importance of steam power to the mining industry. Even in the busy coal fields, however, something of the past has survived the constantly shifting tide of improvement and modernisation.

The north-east of England has an association with coal mining that goes back for centuries: they were sending coals from Newcastle to London at least as early as the thirteenth century. At Beamish, in the North of England Open Air Museum, a pit-head scene has been recreated as it might have been a century ago. The most prominent building is the tall, narrow, stone engine house, which was removed from its original home a few hundred yards away and rebuilt on the museum site. It looks very different from Crofton because it houses a different type of engine. When the Boulton and Watt patent expired, inventors rushed forward with new ideas, and Phineas Crowther of

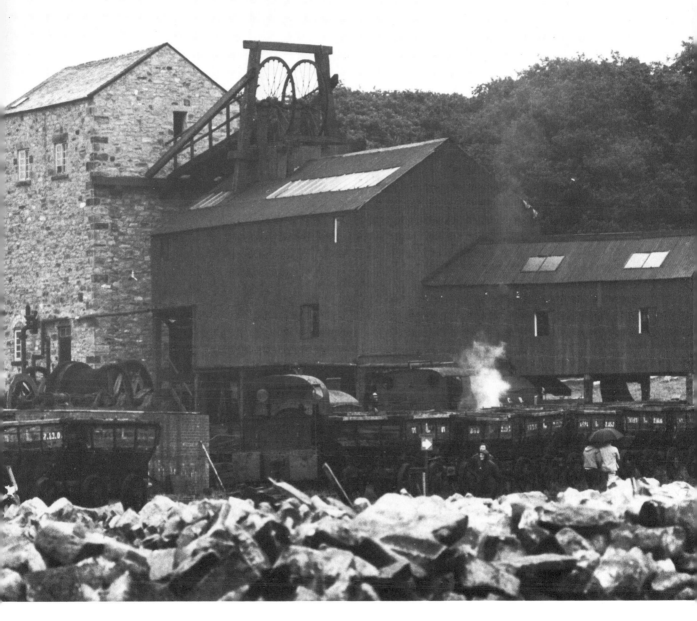

A typical nineteenth-century pit-head scene recreated at the North of England Open Air Museum, Beamish. The stone building houses the steam winding engine.

Newcastle was quick off the mark with his vertical winding engine of 1800. This particular example was built in Newcastle in 1855. It does away with the beam of the Boulton and Watt engine, by placing the winding drum immediately above the cylinder. The piston drives the drum directly, its movements controlled by pivoted beams and a 20-foot diameter fly wheel.

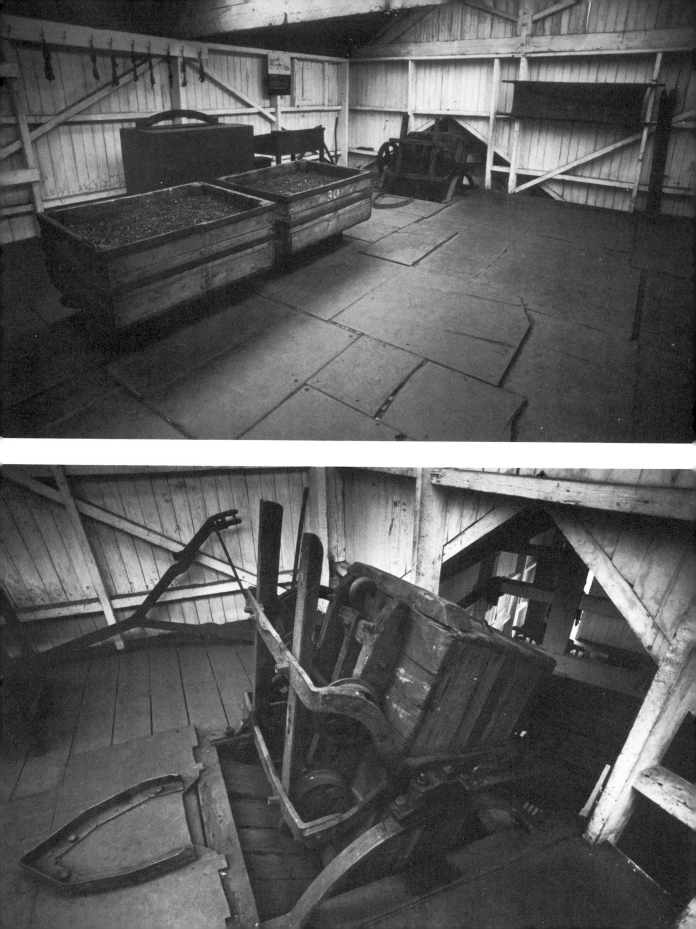

From the winding drum in the engine house, cables pass out to the headstock above the shaft. As this is out of sight of the engine man, he has to gauge the position of the cage in the shaft by indicators in the engine house. Stopping and starting is carried out by manipulating the valves. The engine man was a highly skilled operator who could bring his cage to rest in the distant shaft within inches of where he wanted it. A safety mechanism, the bell, prevents overwinding. Above the cage there is a small projection. At the top of the shaft is a plate with a hole in it. Only the rope holding the cage can pass through the hole. If the projection hits the plate, the cage is automatically braked and held. It was a point of pride with the engine man not to see the bell in use – and if he did miscalculate, his mates made sure he didn't forget his mistake in a hurry.

A crudely built shed covers the area around the shaft. Here the coal tubs, or kibbles, emerge. A pair of rails in the bottom of the cage align with the floor of the shed, so that the kibbles can be wheeled straight out to the weighing machine. In working days, two metal tallies were attached to each truck – one with the name of the hewer who dug the coal at the face, the other with the name of the putter who filled the truck. In the nineteenth century all payments were by results, though the system varied between different parts of the country. In some regions men worked as gangs, with the ganger collecting and sharing out the pay. Here, in the north-east, the working unit was made up of just two men – putter and hewer.

After weighing, the kibbles were pushed on to the tipper, a cantilevered platform which tipped up, pouring the load of coal onto the screens. These screens consist of adjustable iron bars. The small coal and dust dropped through to a wagon underneath, while the large coal went on for sorting, when stone and other rubble was removed. The amount of rubbish in each kibble was a matter of some importance to the miner. Too much rubbish and part of the value of the load was lost, and if the proportion rose too high he could lose the value of the whole load. Theoretically, the screens were the impartial judges of what the miners brought to the surface. It sorted out the good coal, for which the miner deserved payment, from the unprofitable waste, for which no payment could be expected by reasonable men. 'Billy Fair Play' was the owners' nickname for the screens – 'Billy One Side', the miners' nickname. The miners knew they could toil for hours underground, working at a spot chosen by the employers, only to be told the coal was not good enough. That waste was in any case put to use in feeding the engine boilers. One man's waste was another man's free fuel.

Beneath the screens, the coal trucks waited on railway lines. Railways began life in the collieries, though at first the trucks were drawn by horses not locomotives. A special type of wagon was developed – the chauldron. The oldest chauldrons can be recognised

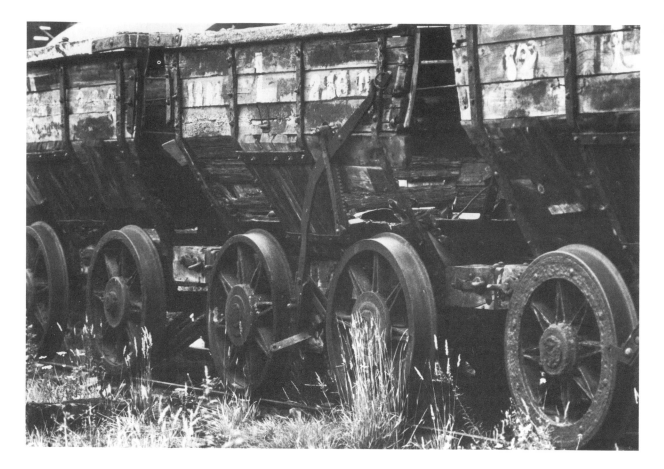

by their square axles, but otherwise the design changed little over the years. The patches on the side of these wagons are reinforcing panels which could be hammered to loosen frozen coals in winter. The chauldrons were dragged away on the rails, and eventually emptied by releasing the coal through traps in the bottom.

Chauldrons: the typical coal wagons of the north-east of England.

A colliery can only exist where there is coal to mine. The collieries followed the coal seams, and around the collieries the villages grew. Often the pit offered the only employment in the area, so it became the heart of the whole community. The cottages that cluster around the pit head are as much a part of the mining scene as headstock and engine house. This has not been forgotten at Beamish. A whole terrace of six cottages, that was once Francis Street, Hetton-le-Hole, has been re-erected close to the colliery. They are typical of many cottages built in the nineteenth century. Essentially, they are one-up, two-down, with the bedroom open to the rafters and lit by dormer windows. The tiny sculleries are housed in a lean-to extension, while the 'necessary' and coal house are across the back yard. The cottages were built around 1850, and lived in until quite recently.

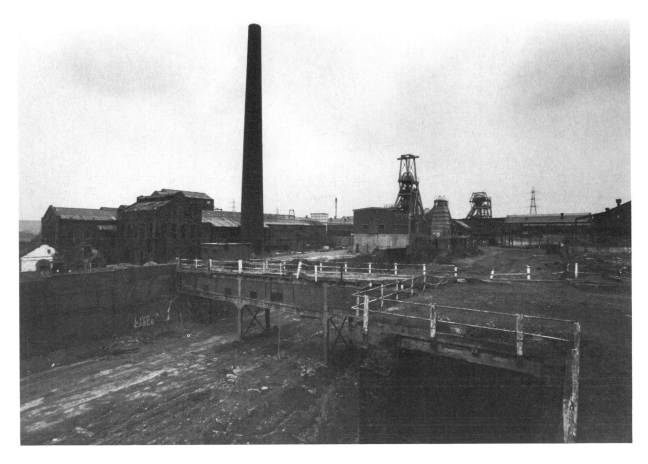

Pit-head scene at the Chatterley Whitfield Colliery.

Collieries are frequently set down in the middle of nowhere, so the villagers did at least have room to spread and to start a decent-sized kitchen garden. Inside, the cottages, though tiny, have the particular characteristics of the community. In the nineteenth century, the miners went in for solid, but rather grand, furniture – huge mahogany chests, bright brass bedsteads, colourful ornaments. Perhaps it was a reaction against the dark world in which the miners spent their working lives. The furnishings of the Beamish cottages capture something of this special atmosphere.

The surface signs of mining, engine house and whirling headstock gear, are familiar to most of us. The underground world remains a mystery. At Chatterley Whitfield Colliery in Staffordshire, there is a chance to explore that world. Coal has been dug in the region for a very long time, but the existing colliery only began to take shape in the 1850s. Hugh Henshall Williamson sank a number of exploratory shafts down to the different seams. From then on, the story is mainly one of steady expansion, which was given a great boost when the

Whitfield Colliery Company amalgamated with the Chatterley Iron Company to form Chatterley Whitfield. The heyday of the colliery's life came in 1900 when it became the first British colliery to top the million-ton-a-year mark. Decline set in in the post-war years and in 1977 the pit was closed. With most pits that would have been the end, but Chatterley Whitfield is being preserved as a museum for the mining industry.

When you first come to a colliery, the surface buildings often seem to be little better than an incoherent jumble. It only begins to make sense when you realise that they relate less to each other than to the hidden world underground. The most prominent features are the headstocks, marking the positions of the different shafts, and each of those shafts has its own associated set of buildings. They also have their own names. At Chatterley Whitfield the oldest, and shortest, are Albert – not much doubt about when that was sunk – and Laura. The others are Hesketh, Platt, Institute, Engine, Winstanley and, when someone presumably ran out of ideas, Middle. Each has its own buildings, and each contributes to the overall plan.

In the 1860s the colliery drove a railway through to Longport, so the layout is designed to get the coal up from the shaft, screened, cleaned and loaded onto the railway trucks. You can see the pattern most clearly at the Hesketh shaft. It has a very prominent engine house, inside which is a magnificent steam winding engine. It was built in Wigan in 1914 and is very different from the early engines we have already looked at. The basic difference lies in the use of the driving force of the steam. Watt had always used low-pressure steam, but here the steam is under high pressure and it is the expansive power of that steam once the pressure is removed that does the work. The two cylinders are set horizontally and drive the drum through a crank and flywheel. It is a massive engine, but nowhere near as big as the early beam engines. Its work capacity, however, is at least as good. It wound men and coal up the 651-yard shaft, and could move 300 tons an hour. One point to note is the valve mechanism which controlled the movement of steam into and out of the 3-foot diameter cylinders. These are very efficient rotating Corliss valves, named after their inventor George Corliss. He designed them in 1849 and, unlike most of the inventors whose work we shall be seeing, he was not British but American. It is just one indication of the way in which, by the middle of the nineteenth century, Britain's early industrial lead was beginning to slip: the rest of the world was catching up.

The engine wound the tubs of coal to the surface and up to a point high above the shaft. From there they continued their journey down again, helped by gravity, through the rather rickety looking buildings that cover screens and sorting bays, eventually being tipped into trucks in the railway cutting. Essentially this is the same system as at Beamish, but on a larger scale. Similar buildings stand

Part of the magnificent steam winding engine at Chatterley Whitfield.

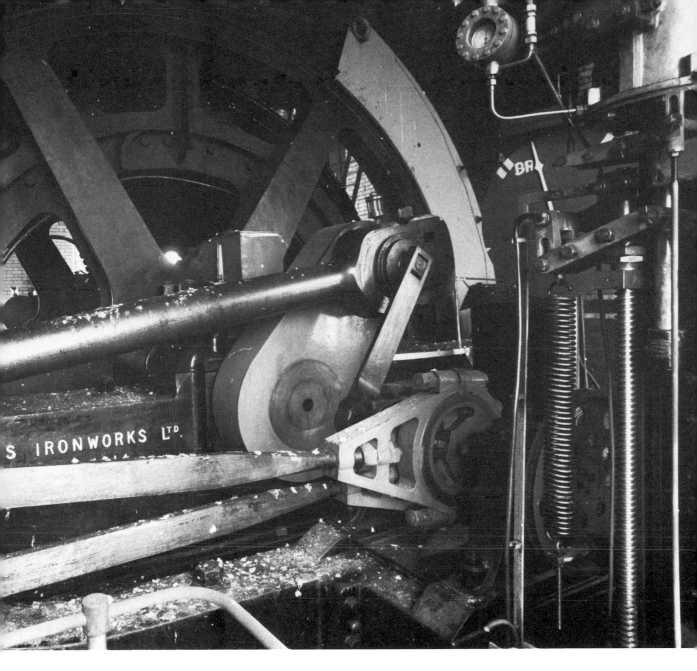

over other shafts, and in between are the offices, bath house, lamp house and the rest of the surface buildings. None of this, however, gives any indication of the extent of the workings beneath the surface. The mine proper is a complex three-dimensional maze of shafts and galleries. From the colliery yard you can look out across the valley to Tunstall church more than a mile away: underground you could walk to a point beyond that church. This underground world covers an enormous area, and the great fascination of this museum is that visitors will have the opportunity to see it for themselves.

The visitor has to be kitted out with the basic equipment of the miner: hard hat with lamp, self rescuer that provides an emergency supply of air and, like every working miner, he is given a quick

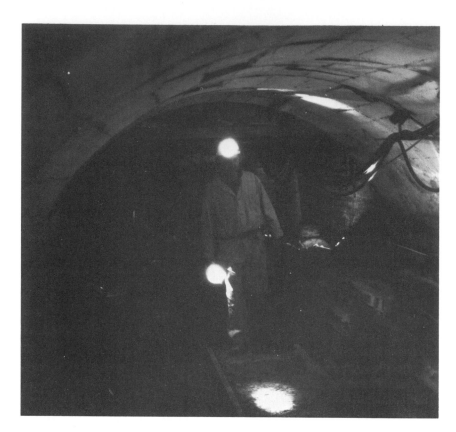

One of the wide main roadways underground at Chatterley Whitfield.

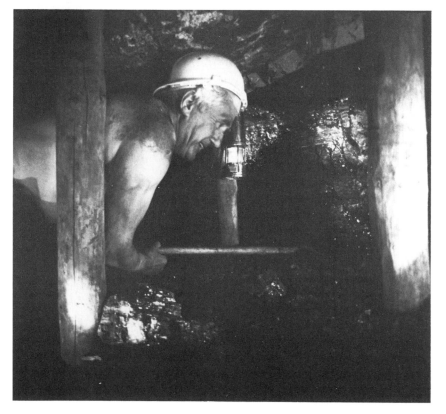

A demonstration of the old method of hand working.

frisking for anything that might start a fire. This may be a museum now, but safety is no less important. The ride down the cage is comparatively short, just 249 yards, but distinctly rapid. Two things strike you at once: there is a good deal of space at the bottom of the shaft and a gale force wind is blowing through parts of the system. The space is needed, for this was one of the major roadways which had to take a busy traffic in trucks, each holding around half a ton of coal, and dan wagons, flat trucks which were used to shift machinery underground. The wind is no less essential. Lethal methane gas tends to accumulate in mines and good ventilation is absolutely necessary to keep the air pure and minimise the risk of explosion.

Two shafts are needed to keep a mine ventilated and, in its essentials, the system has not changed very much in the past hundred years. Fresh air passes down one shaft, the downcast, is channelled round all the workings and then leaves via the upcast. Originally this was achieved by placing a furnace at the foot of the upcast, so that as the hot air rose it dragged down cold air to replace it. Furnaces down mines seem an obvious recipe for disaster, and so it proved. In 1882, fire spread from just such a furnace at Chatterley Whitfield and 24 miners died. In modern pits, a fan is used to suck the air through. Left to its own devices, the air would simply take the shortest route from downcast to upcast, so an elaborate system of airtight doors is used to close off the short cuts to keep the air moving round its full course. A century ago, the responsibility for opening and closing these doors fell to young children, the trapper boys, who spent their days alone in the dark galleries. At Chatterley Whitfield only a small portion of the colliery is now open, so the air path is short. In working days, the air would have had to travel many miles and by the time it reached the upcast, it would have been hot and clammy with moisture. In spite of the care taken with ventilation the miner's lamp is still used as an indicator to show up traces of gas. In the presence of methane, the flame burns blue.

Along the roadway is a small workshop for the maintenance of mine machinery, a reminder that the bulky equipment in use underground has all to be brought down in pieces and assembled. It is only taken back up if absolutely necessary, so maintenance and repairs have to be carried out below ground. The mine maintenance man had the same job as his colleague on the surface – with this great difference that he had to carry out his work in the dark, cramped and grimy conditions underground. Further on there is evidence of just why the big pumping engines were needed, for the sound of running water can be clearly heard. A turn brings you to an underground cross roads. 'Cruts', passages which lead off through the rock to other coal seams, meet the main roadway. Here one can see the bare rock wall and the pressures exerted by the great mass of earth above the old tunnels have left their mark in twisted beams and broken props.

45

The route now follows a passage which once held the stables where the pit ponies had their homes. Before the ponies came underground and roadways were built high and wide, the work of moving the tubs of coal fell to the men and even, in an earlier period, women and children. Often they were forced to crawl on all fours, hauling the heavy trucks like so many underfed pack animals.

Beyond the stables is the coal face. In this part of the mine the coal can be seen exposed as a sandwich-filling some three feet thick, held between sandstone above and fireclay below. There are two main methods of working the coal, 'pillar and stall' and 'longwall'. In the

Pit ponies once worked at Chatterley Whitfield. Now all that remains is the name of one pony, Blackie, on his stable wall.

The movement of the earth frequently causes roof supports to buckle and crack.

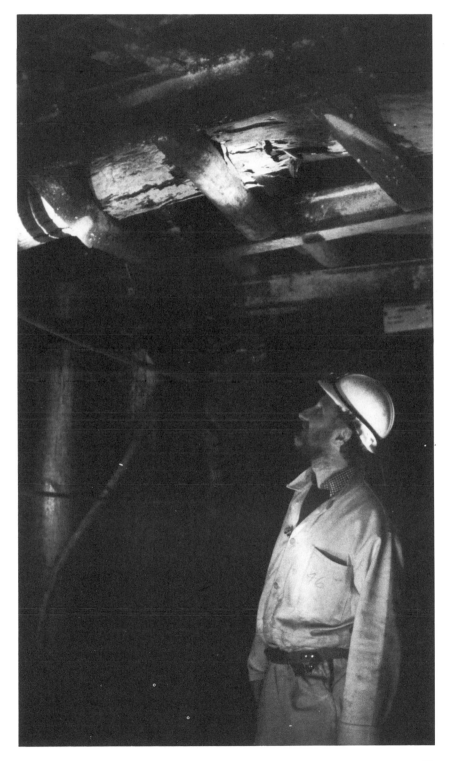

former, each miner works his own individual stall, and moves forward leaving thick pillars of coal as support for the roof. Then the miner moved back again, putting in props and systematically 'robbing the stalls' on the retreat to the shaft. In deep mines there was a tendency for the pillars to collapse and longwall working was introduced. Here, as the name suggests, the miners remove the coal in a long line, working across the seam. Headings are dug into the coal and the face gradually extended. This method is particularly well adapted to modern machine cutting and the new hydraulic props which can move with the face, allowing the old face to collapse behind them. In the early days of longwall working, the miners themselves had to remove the props left behind by the advancing face. This was generally reckoned to be the most dangerous job in the whole mine. Those days, when coal was won entirely by pick and shovel are, happily, gone, but even now the initial space in which the machines are set to work has to be cleared by hand.

No museum can hope to recreate the life of the early mines: and no visitor would wish to experience it. Here the seams are wide, but elsewhere men lay on their sides in seams no more than eighteen inches deep, attacking the coal with no help from any machinery. Mercifully, mechanisation has removed much of the grinding labour of the mines, but it has not yet removed the darkness, the choking dust or the danger. The visitor to Chatterley Whitfield will learn something of the techniques of mining and he will get a glimpse of the working world of the miner – but only a glimpse.

The first iron age began around 1200 BC in the Middle East, but it took several hundred years to reach Britain. Iron occurs naturally as an ore which contains the oxide of the metal. This can be reduced or smelted – that is, the oxygen can be removed by heating with carbon. One of man's great imaginative leaps came when he first recognised that this particular type of rock could be made to yield a metal infinitely more useful than much-prized gold. Who this inventor or group of inventors was we do not know, nor do we know how the discovery was first made. But whoever was responsible deserves a place on the highest plinth of the technological pantheon.

In early times the carbon used in smelting was generally in the form of charcoal. Heat a mass of iron ore and charcoal together and you get a rather spongy lump of iron which can be hammered out into different shapes for tools, weapons, horseshoes and the like. This is what we know as wrought iron. Later it was discovered that if you built a larger furnace and increased the temperature by blowing air through the fire, you could melt the iron and run the metal off into moulds. This was cast iron, which was first made around the fifteenth century. Whichever process was used, charcoal still had to be the fuel. Coal, unfortunately, was not suitable as it contains too many impurities.

Iron was, like coal, fundamental to the development of the industrial revolution. Engines and machines were constructed from it, rails were made of it and buildings built on frames of it. The potential for iron use was enormous, but at the beginning of the eighteenth century there was no similar potential for increased production. The trouble lay with the fuel – charcoal. This was not a problem in heavily forested areas such as Scandinavia, where wood for charcoal making was plentiful. In Britain, however, the problem of charcoal supply was bad and getting worse. The forests were shrinking and the iron masters were not the only customers for wood: the demands of the ship builders were even greater. As a trading nation with an expanding empire Britain could not neglect her merchant fleet, nor her navy. A 1500-ton man-of-war, of the type being built in the seventeenth century, needed the wood of some 2000 oaks. 50 acres of woodland had to be felled for just one ship. If iron production was to meet the needs of the day then an alternative to charcoal had to be found. It was, by a Bristol Quaker named Abraham Darby.

Darby's early life provided him with two useful introductions. As an apprentice, he worked in maltings where he came across the use of coke as a fuel. Coke is made from coal, not wood, and in the manufacture the sulphur which made coal unusable for iron making is removed. It is also very strong, which means that a great quantity of fuel can be stacked up without being crushed. After his apprenticeship in the maltings, Darby joined in a partnership to form the Bristol Brass Wire Company in 1702. Two years later he set off to investigate

Right
The iron beam of one of the two Crofton steam engines, showing Watt's parallel linkage.

Previous page
The giant water wheel, Llanberis.

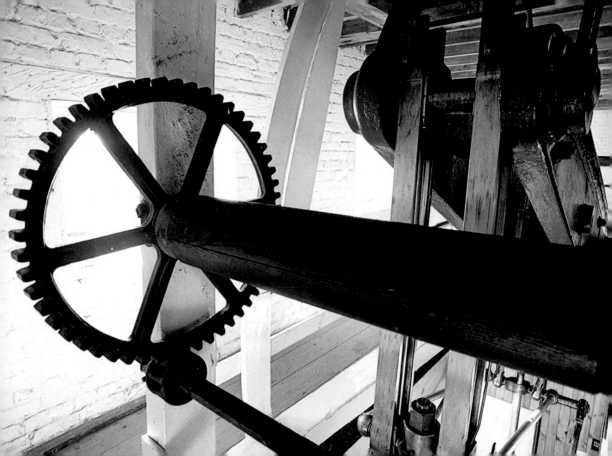

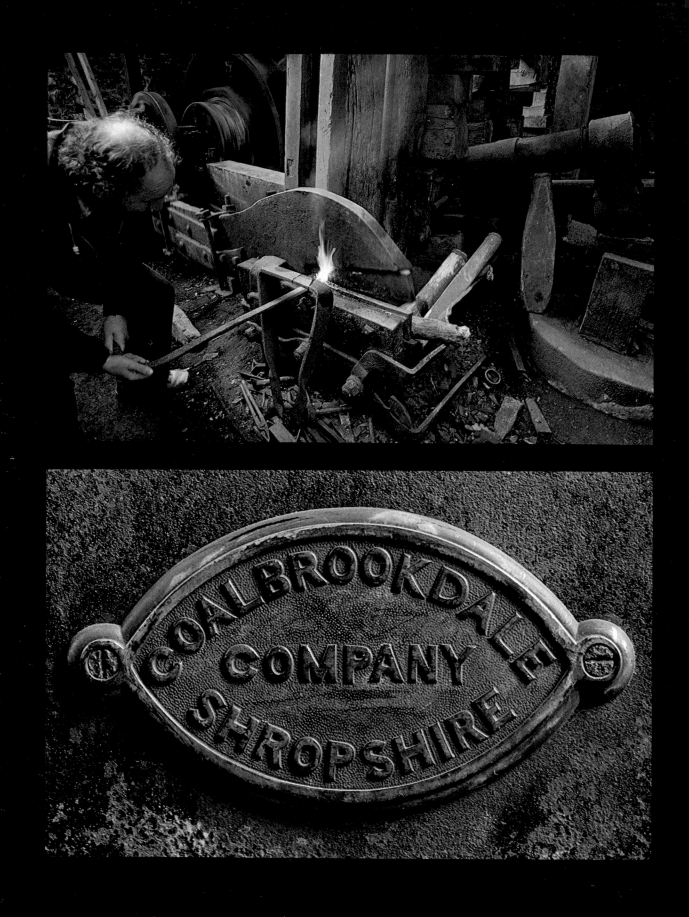

Above left
The author cutting a metal bar with the water-powered shears, Finch's Foundry.

Below left
Name plate from a Coalbrookdale locomotive.

Right
Cast-iron pots of the type manufactured by Abraham Darby at his new works at Coalbrookdale.

Dutch methods for making brass pots, and was introduced to the process of casting. Now his interest moved from brass to iron, and he was struck by the idea that there could be a profitable business in producing cast-iron cooking pots. In 1707 he took out a patent for casting iron pots in sand. He gave up the brass business and set out to look for a site where he could combine the two notions – using coke as a fuel and casting in sand. He came to Coalbrookdale in Shropshire and it was here, in 1709, that the first iron flowed from a coke-fired furnace. It was the beginning of the new iron age.

Iron is still produced at the Coalbrookdale works, but part of the site has been set aside as a museum. Here one can see Darby's original furnace and the care and ingenuity that went into the planning of the whole site. Coalbrookdale is a valley cut by a tributary of the Severn, then a navigable river, busy with trade. The works were

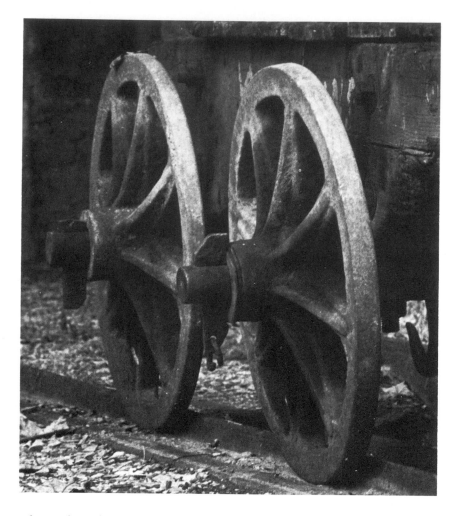

The Coalbrookdale works produced many important items for early industry, including these iron wagon wheels and the rails on which they run.

planned so that raw material was collected on the uphill side of the works and process followed process down the hill until the final stage was reached when the finished product arrived on the wharf at the river. A good starting point is the Darby family home high on the hillside. From here one can look across and see a row of cottages, Carpenter's Row, which once housed Darby workers. The Darby house is not especially grand and the workers' houses are not mean. Relationships between the Quaker Darby family and their work force were, in general, very good.

At the very top of the working site is the furnace pond, made by damming the river. Water from the pond could be released to fall onto an overshot water wheel. This was used to work the bellows which provided the blast of air to the furnace. Beneath the high retaining wall is the square, brick block of the old furnace. It may not be the most impressive, and it is certainly not the most beautiful historical monument, but it is of the greatest importance. It was from this structure that the first iron of the new age flowed. Originally the furnace was connected by a bridge to the top of the furnace pool dam. Up here, in the north-east corner, were the coking hearths. The coke, together with limestone, which acts as a flux to carry away impurities,

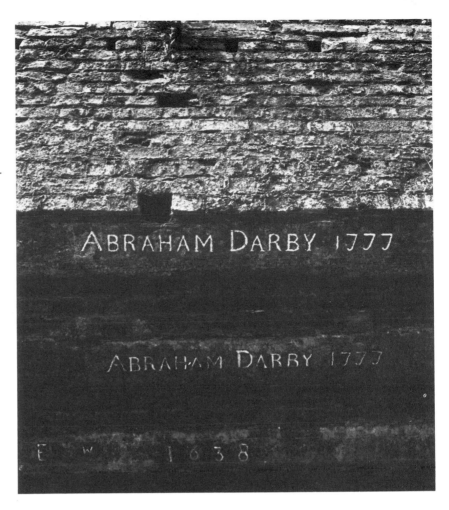

The lintel over the hearth of the old furnace at Coalbrookdale: the date 1777 marks the enlargement of the furnace for the casting of the iron bridge over the Severn.

and the iron ore, formed the charge for the furnace. The charge was taken across the bridge and tipped directly into the top of the furnace.

From the top one can see that the square box is no more than an outer cladding for the circular furnace. It is about six feet in diameter at the top, widening out to around twelve feet and then tapering in again at the bottom. Beside the furnace is the pit in which the water wheel once turned and on the south side of the furnace is an arch, known as the tuyere arch, through which the air pipe was passed. On the eastern side is another arch with inscriptions that tell much of the history of Coalbrookdale. This is the arch through which the molten metal was tapped. The lowest lintel carries the date 1638, for this was a charcoal furnace before Darby came to Coalbrookdale. Darby was, in fact, hedging his bets. If the new coke smelting failed then he still had a workable charcoal furnace in an area thick with woodland. In fact, he was luckier than he could have expected, since the clod coal found locally was ideal for coking. Above that are two other beams with the name Abraham Darby and the date 1777. These record the time when Abraham Darby III had the furnace enlarged to cope with the biggest task the works had undertaken. 370 tons of iron had to be cast, taken down the river and there assembled into the

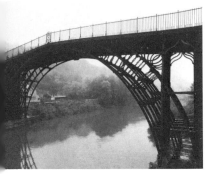

The world's first iron bridge designed by Abraham Darby III. The various parts of the bridge were treated as timber rather than iron, being slotted together or jointed.

great arch across the Severn that has given the town of Ironbridge its name. This is the world's first iron bridge, and is both beautiful and rather odd. It was a pioneering work and the builders were uncertain about how to use the new material, so they simply adapted older techniques. The iron members are treated as though they were wood, jointed and slotted together.

The Darby works had a reputation for fine casting and they had some important customers. They manufactured steam engine parts for Boulton and Watt. They made iron rails for many concerns, and in 1803, steam engine and rails met when they built a locomotive for Richard Trevithick. At one time it was believed that the first successful test of a locomotive running on iron rails was made by Trevithick at the Penydarren tramway in North Wales in 1804. It now seems more likely that the honour of being first in the field belongs to Coalbrookdale.

There is a gap of about 70 years between the first successful experiment with coke smelting and the building of the iron bridge. The world did not beat a path to Darby's door in 1708. By using coke he had got rid of the problem of sulphur contamination, but the coke now introduced other impurities. The Darby iron was very brittle, and much of it went to making the humble nail. It was only in the middle of the century, when coke production had been vastly improved by the use of closed, brick coking ovens, and the quality of the iron had been further improved by reheating in a second furnace, that coke-smelted iron could match the product of the charcoal furnace. Once that stage was reached, however, progress was very rapid.

The Darby works prospered and spread. More buildings were added, such as the warehouse with its ornate clock tower, which houses the main museum exhibits. A second warehouse was built down by the river. Follow the road down towards the Severn and you come to the extraordinary Gothic warehouse, complete with all the trappings of a medieval fortress – battlements, turrets, arrow slits and buttresses. The warehouse was linked to the site by a plateway, a form of railway made out of right-angled iron plate, into which the wheels of an ordinary wagon wheel could fit. Part of the plateway can be seen at the wharf, outside the building. Here the iron was stored before being shipped. Much of it was pig iron, so called because it was cast in a series of troughs running off the main channel at the foot of the furnace, and was thought to look like piglets feeding from the sow. Pig iron was also available to other iron workers: it could be cast in the foundry or hammered into shape at the forge.

The Darby works were and still are a foundry, but it is not easy to see that side of the activity at the museum. Throughout the country there were other foundries producing everything from bridges to kitchen ranges. The foundry was an essential part of the industrial scene, and many industries ran their own small units.

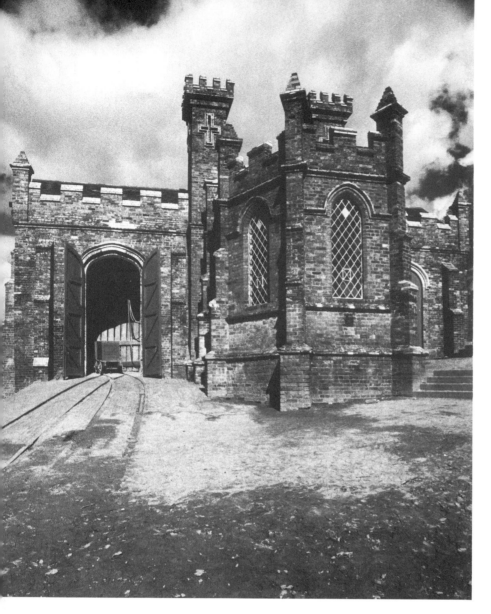

One of these can be found in North Wales where the major industry was, and to some extent still is, slate. It was mined and quarried and sent out to roof the industrial towns of Britain. One of the most important centres was Llanberis at the foot of Snowdon. The Dinorwic quarry was begun here in 1809 and gradually, over the years, has extended across the face of the hill until now the spectacular terraces rise to a height of 2000 feet above the quarry floor beside Llyn Peris. At its busiest, the quarry employed over 2000 men and in 1870 the Company decided they needed their own workshops to look after the machines, to repair those which were old and broken and, where necessary, to cast new parts. The aim was to make the quarry virtually self-sufficient.

The buildings are grouped around a quadrangle, rather in the style of a military barracks. Built of granite, with, inevitably, slate on the roof, they are handsome rather than beautiful. The front façade is

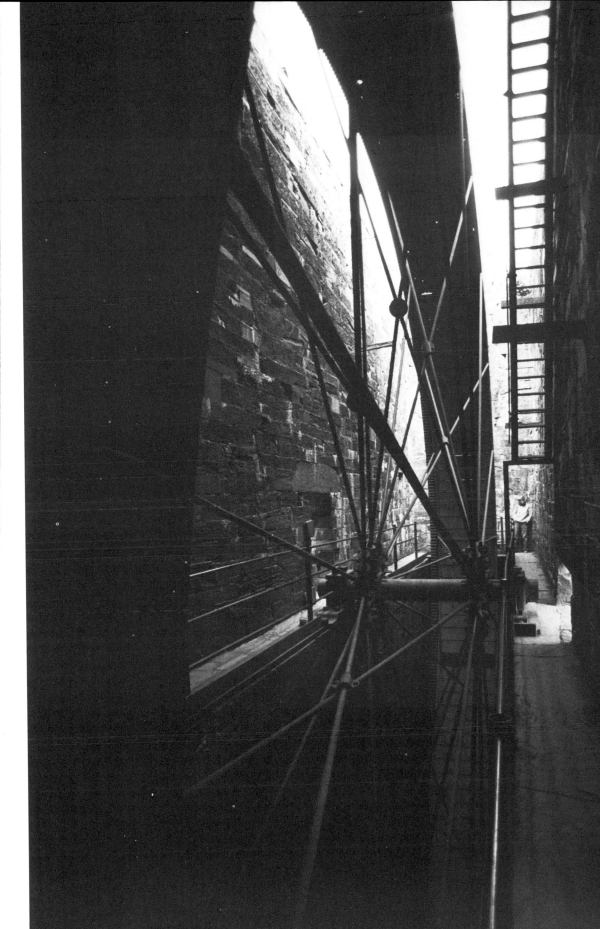

symmetrical with towers at either end, but this symmetry disguises a multiplicity of buildings behind. There are saw mills and joiners' shops, blacksmiths, carriage repair works, a locomotive shed for the narrow gauge railway that served the quarry and many other workshops. Power was needed, and this was supplied by a massive overshot water wheel, 50 feet in diameter, the second largest in Britain, surpassed only by the famous Loxey wheel in the Isle of Man. Water to feed the monster was brought three-quarters of a mile from Llanberis waterfall. The wheel was working until 1925 when it was replaced by the smaller and more efficient Pelton wheel, a kind of turbine, which still works. The maintenance buildings are now home to the North Wales Quarrying Museum, which shows something of the way of life of the quarrymen. Part of the old joiners' shop, for example, has been refurnished as a hospital, a building that would have been much in use, for accidents on the high faces were common. The doctor in charge of the quarry hospital in the 1890s, however, seemed less concerned with accidents than with other evils. He put out little homilies for the workers, such as 'Remember there is no goodness in tea'.

A system of pulleys and shafts transmits the power from the water wheel to the machinery of the slate quarry maintenance works.

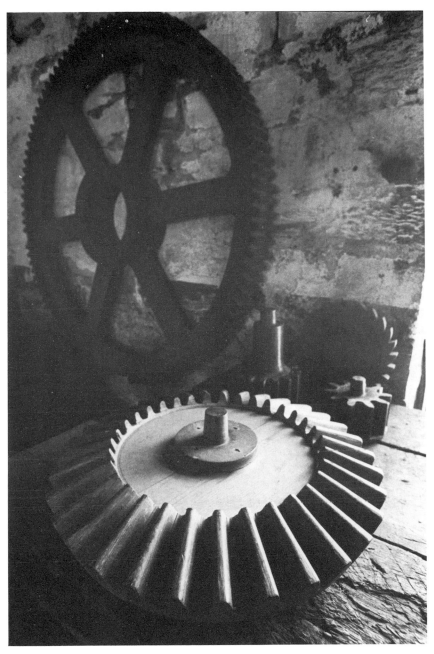

Above and right
*Wooden patterns for machine
parts. Before a machine part
could be cast in metal the
wooden patterns had to be made
by skilled craftsmen.*

The main interest, as far as the story of iron is concerned, lies in the foundry, sited in a two-storey building at the back of the quadrangle. Here castings were made by pouring molten metal into a moulding box containing sand, into which a pattern of the object to be cast had been pressed. So, the logical place to begin is in the pattern maker's shop on the upper floor.

The patterns were first made in wood, and the pattern maker needed to be a craftsman of considerable skill. To help him he had an array of drills, saws and lathes, each driven by a pulley from a shaft turned by the water wheel. Many of these tools had been designed by

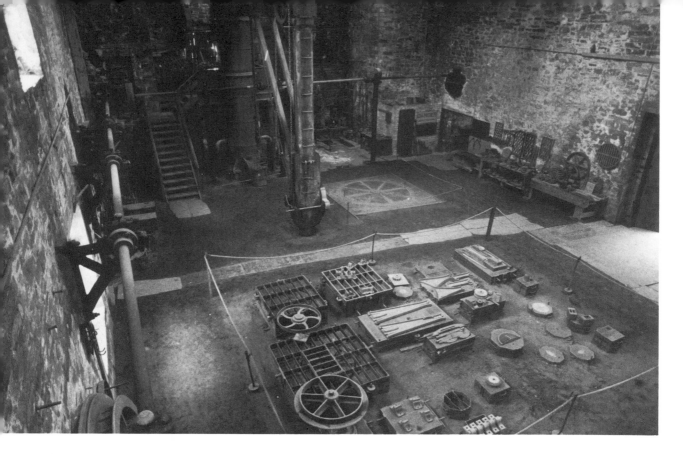

the pattern makers themselves. He also had his own supply of carefully tended hand tools. With these he was expected to turn out anything the works might require – from complex machine parts to foot scrapers for the office door and little flat irons that went as perks to the quarrymen's wives. The pattern store is an Aladdin's cave of beautiful objects made in wood, none the less beautiful because they were made for use rather than for admiration in a gallery.

The wooden patterns were taken and pressed into the sand of the moulding boxes and removed, leaving behind an exact impression in the mould. Raising and lowering the moulds was a delicate business and a wooden jib crane on a high wooden column was used. The metal came from a tall, cylindrical furnace or cupola. It was loaded with pig and scrap iron, with coke as a fuel. The molten metal was run out along a short launder to a ladle like an over-sized spoon. This was manoeuvred into position by the crane and the metal poured into the mould.

The work of the foundryman was a true craft, requiring a high degree of skill and experience. The skill of the pattern maker is obvious – you can feel the perfection of the work through your fingers as you handle the wood – but the art of the foundry is less easily appreciated. It is a matter of judgement, of gauging temperatures, of picking the right time to pour. It requires strength as well as skill to handle a ladle of molten metal when your hands are slippery with sweat from the heat of the furnace. The Llanberis foundry is a small affair compared with the Darby works, but the skills and technology are the same.

The forge was the other great user of iron. It appeared long before the industrial revolution, for it was already an established part of the iron industry by the sixteenth century. It was, in effect, the old black-smith's shop writ large. Iron was brought from the furnace and heated in a 'finery', where most of the carbon was removed. It was then reheated and hammered into shape on an anvil. The blacksmith relied on a strong right arm for power; the hammers of the forge used the power of water. Most have long since disappeared from the original iron making centres, such as the Weald of Kent, where the industry was established to take advantage of the forests essential to charcoal making. All that is left are the hammer ponds where water was held to turn the wheels that powered the hammers. Iron making moved on to South Wales, the Black Country, Yorkshire, Lancashire, Scotland and other areas rich in coal as soon as a way was found to make wrought iron out of the cast iron from the coke furnace.

The problem of converting cast to wrought iron was solved simultaneously in the 1780s by Peter Onions and Henry Cort, but it was Cort's method that came into general use. It was known as 'puddling'. The cast iron was heated in a reverbatory furnace, that is, one in which the fuel and the iron never come into direct contact. The molten metal was continuously stirred to allow the hot air to circulate through it. The carbon of the cast iron was oxidised and pure wrought iron left. Puddling was one of the most arduous trades in early industry. The weight of the iron was immense, the heat from the furnace terrific. The men sweated off pounds every working day and local pubs did a roaring trade as the men came at the end of the day to put the liquid back in again. Cort was also responsible for introducing grooved rollers for bar iron. The hot metal was squeezed through, and it proved far quicker and more efficient than the old technique of hammering the iron out into a bar.

The iron forge changed, but it certainly did not disappear. The techniques and machinery of the forge were widely used, particularly for making tools, and they continued in use for a surprisingly long time, right through into the present century. One such forge, where work only ended in 1960, can be seen at Sticklepath in Devon. Its name is somewhat misleading – Finch's Foundry – since, as far as one can tell, there has never been a foundry there at all. It is a forge where agricultural tools and tools for the china clay industry have been made since the early nineteenth century.

Finch's Foundry is a particularly interesting site with a good many lessons to teach. For a start, it provides good examples of both the adaptability of early industrial buildings and the versatility of the water wheel. Sticklepath was a busy place long before the iron workers came. It was an obvious site for development, set conveniently on the main road from Exeter to Okehampton and with the River Taw flowing through to supply power. A succession of mills stretched

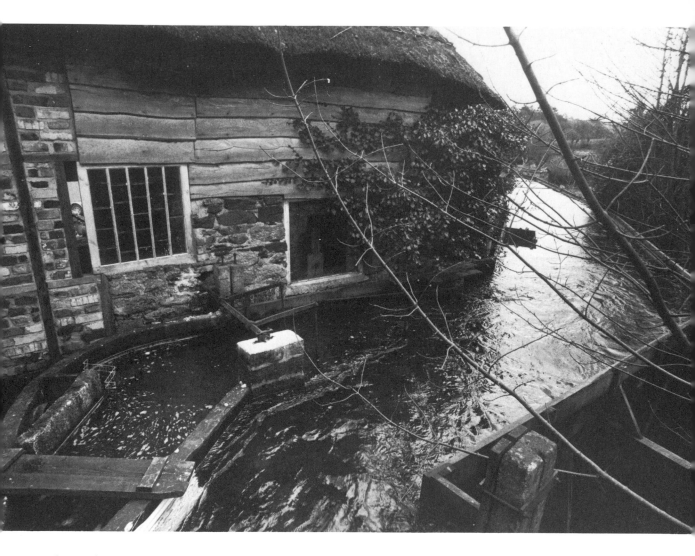

down the river, some making serge cloth, others grinding corn. The present buildings may look as if they belong together, but when William Finch came here in 1814 he took both a cloth mill and the adjoining grain mill for his works.

 The starting point for a visit to Finch's is water, the source of all power to the forge. The mills of Sticklepath are served by a leat or artificial channel. The Taw is dammed up at the top end of the village and water reaches the forge through the launder, a simple wooden aqueduct. It falls first onto an 11-foot diameter overshot wheel on what was once the grain mill and is now the grinding shop. It then goes on to the slightly larger wheel that drives the hammers in the former cloth mill, and finally reaches the fan wheel, which is where we can begin to pick up the story of the forge.

Above and right
Finch's Foundry, Sticklepath. The machines of the forge are water-powered; the water is led along a wooden launder at first floor level, and from there the water falls on to a series of over-shot wheels.

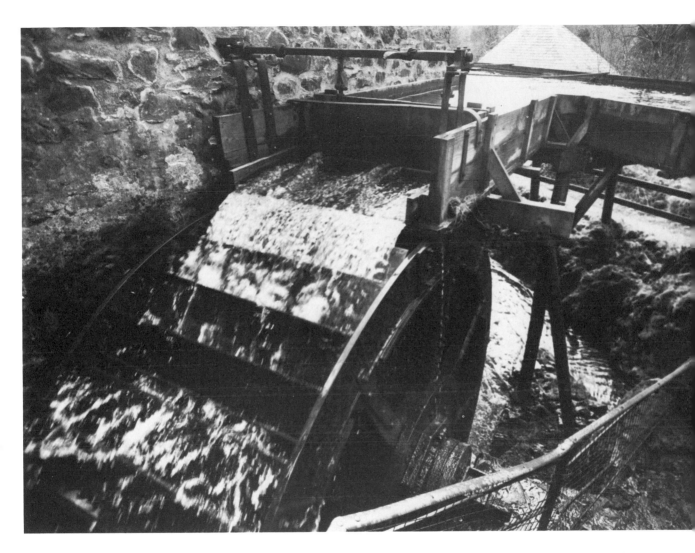

 The fan wheel, not surprisingly, drives a fan. This replaced the bellows of other old forges. The air was blown through underground ducts to supply a blast to the hearths where the metal for the forge is heated. Three hearths can be seen in the next part of the building – the hammer room. It is not difficult to see how the name originates for the big hammers totally dominate the space. The main work was done by two tilt hammers, which are technically of the 'tail helve' type. These hammers are held in a frame, their heads resting on the anvils. As the water wheel turns, the shaft rotates and this turns two tappet wheels set at the butt end of the hammers. The cams connect with the hammers, lifting the heads and letting them fall back on the anvils as the cams clear. One hammer has sixteen projections, giving a striking rate of sixteen per revolution. The other has twelve. The

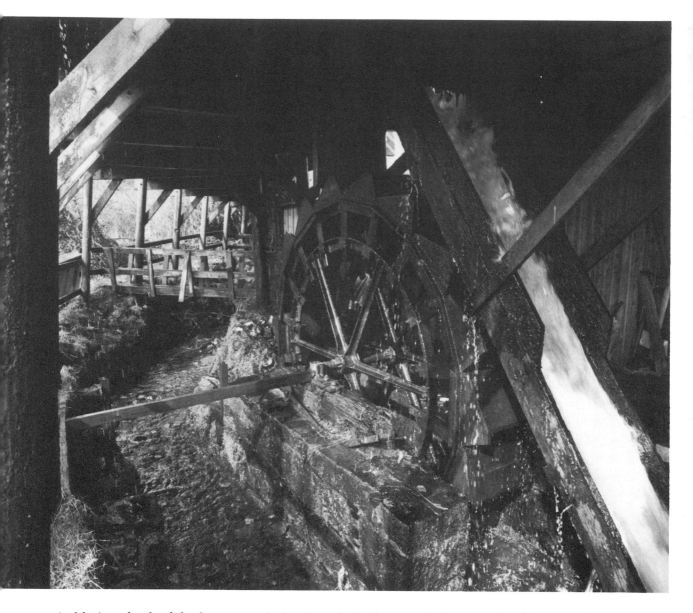

juddering shock of the hammers shakes the whole frame, and if you look closely you can see that it is kept in position by a motley array of struts and wedges which might give the impression that someone made serious miscalculations when setting up the works. Not so! Those wedges have an important part to play, for they enable the hammer man to shift the position of his hammer to lengthen or decrease the drop.

The main output of the forge was agricultural tools. Five men could produce 400 hoes in one working day. First the metal was heated in one

Overflow water from the launder rushes past one of the Sticklepath water wheels.

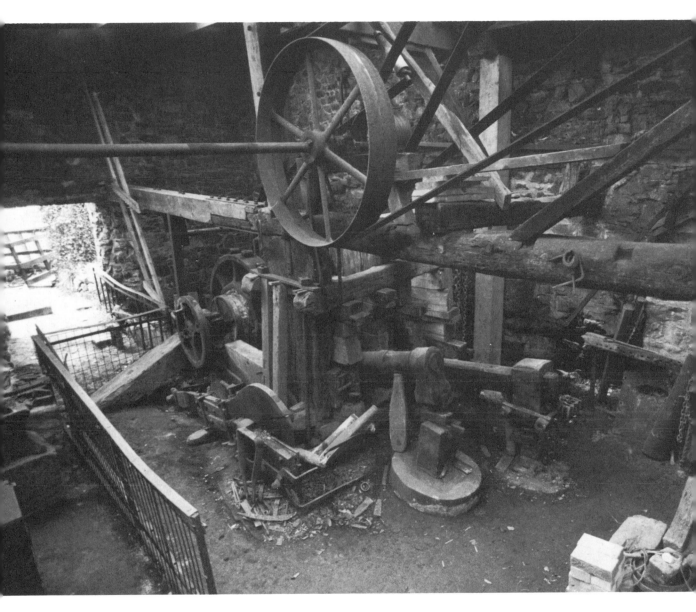

The hammer room at Finch's Foundry. Agricultural tools were shaped on the anvils beneath the two water-powered tilt hammers.

of the hearths. The heads of the hammers were changeable, and a suitable head was selected for the job in hand. Then the hot metal was placed on the anvil and shaped under the pounding hammer. The roughly shaped tool was then trimmed by a set of shears, rather like giant scissors, also worked from the same water wheel. Instead of tilt hammers, a drop hammer could be used. Once again power came from the water wheel. This time a pulley and shaft system was used to lift the hammer head which dropped between vertical shafts. Final shaping was done on hand anvils.

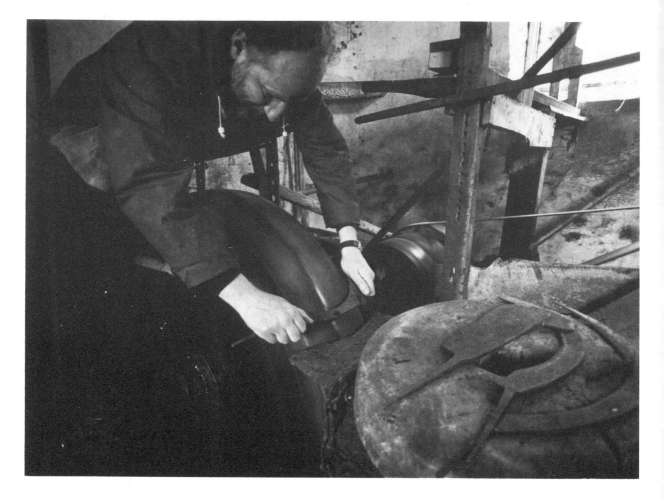

Anyone coming into the hammer room for the first time might well think he had entered a world where the presiding genius was Mr Heath Robinson. The extraordinary array of devices seem to be held together by faith rather than any obvious mechanical principle. Yet it all works extremely well. This is another lesson taught at Finch's. Advances in the industrial revolution were seldom made by theorists but by practical men working in the jumble and apparent disorder of the everyday world.

In between the hammer room and the grinding house, there was once a saw mill where tool handles were made and fitted, but this has now gone. The grinding stone, however, is still there. Here the tools were given their sharp cutting edge. It is a most alarming operation. You lie at full length, holding the blade to the whirring stone just beneath you – keeping your nose to the grindstone is a phrase with real significance here. It feels dangerous, and indeed it is. If the stone broke, the pieces would fly off in all directions like so many small

Above
Grinding a sickle blade at Finch's.

Above right
The mill village of Styal in its attractive country setting.

Below right
The Apprentices' House, Styal, home to more than a hundred mill children.

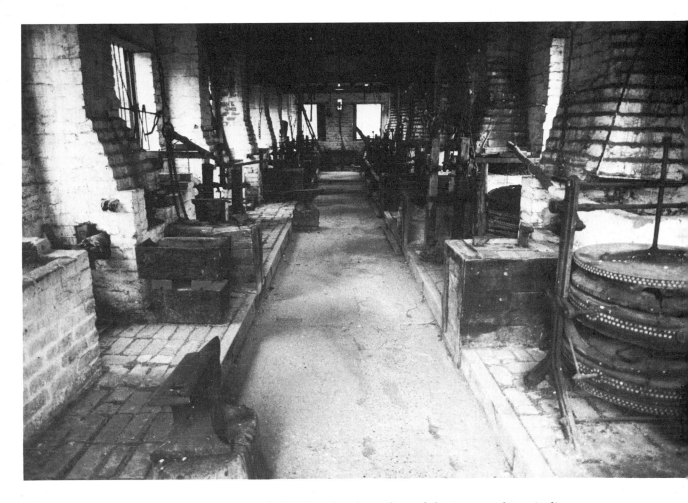

Above
A typical Black Country chain-making shop re-erected at the Avoncroft Museum of Buildings.

Left
The nineteenth-century industrial landscape: the Colne Valley near Huddersfield.

cannon balls. In other branches of the iron trade, grinding was even more hazardous. The cutlery grinders of Sheffield or the needle grinders of Redditch worked in an atmosphere full of fine metal dust which made its way down into their lungs. Few grinders lived past middle age.

The work at Finch's Foundry falls less within the pattern of modern industrial production and has rather more in common with older craft traditions. With slight modifications, the same principle of heated iron being forged under powered hammers could be seen in many parts of the country. In particular, it had extensive use in the Black Country, where the hammer was most commonly powered by a foot treadle. It was used in forging chains, where it was known as a tommy. Metal rod was heated, bent into a U shape, then the ends were reheated, flattened and pushed one on top of the other. The rod was again reheated and the joint welded by the tommy. A smaller hammer, known as an oliver, was used for shaping nails out of metal

rod. Examples of both these typical Black Country complexes – a row of nailers' shops and a chain shop – can be seen at the Avoncroft Museum (see Chapter One).

The continuity of old tradition is one part of the iron making story, but alongside that went rapid developments in technology. Following Darby's early success, the Ironbridge area became a centre of expansion. Furnaces became larger and more efficient. Water-powered bellows and fans were replaced by blowing engines powered by steam, providing a far greater blast. This was further improved when the blast of air was heated. The results of these developments can be seen at Ironbridge in the big, open-air museum. At the entrance is a pair of beam engines, known as David and Sampson, which were built in 1851 and worked at nearby Oakengates. They were able to supply air to the furnaces at the rate of around 12,000 cubic feet per minute. Another blowing engine can be seen, in its original engine house, beside the Blists Hill furnaces. Yet, for all the differences in scale, the fundamental design had changed surprisingly little since the days of the old Darby furnace. This was quite efficient enough to meet the demand for iron that grew as the industrial revolution got under way, although iron was in use for everything from mill buildings to railways.

The most dramatic change brought about by the change from the charcoal furnace to the coke furnace was geographical. Areas which in the seventeenth century had been major centres of the industry declined rapidly, so that today traces of the industrial past have all but vanished. How many tourists visiting the Wye valley think of the area around Tintern as an industrial centre? Yet so it was until charcoal gave way to coke. The new industrial centres were often places which had been wild countryside. At the end of the eighteenth century, the English descended on the valleys of South Wales and built up new towns such as Blaenavon or Merthyr Tydfil. For the Welsh it meant a period of profound social change. Similar changes were being felt in the north of England, where another industry was undergoing a violent transformation. That industry was textiles.

A selection of implements advertised in Finch's catalogue.

Spindle and Shuttle

Textiles in Britain, until at least the middle of the eighteenth century, meant wool, and an industry based on the work done in the cottage. The spinster sat at her door, the spinning wheel turning before her; the weaver worked at the top of the house, throwing the shuttle backwards and forwards across the loom. The whole picture has an air of quiet charm: this was the age of innocence which was to be so rudely invaded by the noise, clatter and oppression of the industrial revolution. Of all the myths of a Golden Age before industry appeared, none has lasted longer than that of the happy weaver, the sturdy independent yeoman.

You can sense something of the background to the myth if you visit the older textile areas. Go, for example, to the village of Golcar high above the Colne valley in Yorkshire. Here you can see the old textile workers' houses, with their distinctive long windows on the upper floors. The first two floors were for living and for the work of the spinsters; the upper floor held the looms, the long 'weavers' windows' providing good light for the work. The houses are sturdily built in stone, plain but handsome – many with views across the valley to the moors beyond. Not surprisingly they are nowadays described in estate agents' windows as 'much sought after residences'. They are attractive and seem even more so in view of the housing that was to follow in the wake of industrialisation.

Turning the fleece on a sheep's back into woollen cloth involved a good many processes and a good many crafts. After shearing, the wool was soaked in urine and water to remove the grease, then beaten to loosen up the fibres. Before spinning into yarn, the fibres had to be aligned by a process known as carding. The simplest method was to pull the wool between two wooden cards, rather like butter pats, studded with wire. In the cottages, this work usually went to children. Now the wool was ready for spinning. This was traditionally women's work – hence spinster, and since the oldest tool used in spinning was the distaff, the female side of the family became the distaff side.

Basically, spinning involves pulling out the fibres, while twisting them together and winding the resulting yarn onto a bobbin. The spinning wheel, which has been in use since at least the fifteenth century, enables spinsters to perform all these actions on the one machine. The fibres were steadily pulled out by hand and wound onto a spindle, while a turning mechanism, known as the flyer, gave the yarn its twist. At first, the wheel was turned by hand, but later a foot treadle was used.

The yarn was not yet ready for use. It had to be unwound from the spindle, a process known as reeling, and prepared for the loom. The loom itself is basically a simple device. Warp thread is fastened round a rigid frame, and the shuttle carrying a spool of weft thread is passed under and over the warp. So, part of the thread had to be wound onto spools for the weft, while the rest had to be stretched over the loom,

Above and below
The old weaving village of Golcar in the Colne valley, Yorkshire. The weavers' cottages can be easily recognised by the long rows of windows on the upper floors providing light for the looms.

Previous page
Mule spinning in the nineteenth century.

usually being prepared on a special warping frame. The warp thread was passed through loops on vertical wires held in the frame. These were attached to treadles so that alternate wires could be raised and lowered. Originally split reeds were used instead of wires, and the name reed has been retained. As the reeds move, so the warp threads separate leaving a gap through which the shuttle, carrying the weft, could be thrown. After each throw, the weft thread was banged into place by a timber baton, and the whole process could be repeated. In making broad cloth, the loom was too wide for one man to span with his arms, so a helper was required to catch and throw the shuttle.

Cloth from the loom had to be washed clean of oil, and it was also beaten to thicken and shrink the cloth, a process known as fulling. This part of the process was mechanised long before the industrial revolution. Big wooden hammers, powered by a water wheel in much the same way as the hammers of the forge, pounded the cloth. It was hung up to dry on tenter hooks – hence another popular metaphor – and was then ready for finishing. First the nap was raised by brushing the cloth with teazles and was then cropped or smoothed out by cutting with hand shears.

As all these processes were so simple in themselves, it might seem surprising that mechanisation was not introduced at an earlier date. In a sense it was. Leonardo da Vinci designed a machine, known as a gig mill, for raising the nap, but such machines were prohibited in England in 1551. It was the start of the long struggle between the proponents of mechanisation and the supporters of the old hand crafts.

The changes in the textile industry before the eighteenth century made little fundamental difference to the rate of production: things gradually got better, but the rate of progress was slow. The first major acceleration came when a gentleman from Bury by the name of John Kay set the shuttle flying. He brought his new invention into the world in 1733. First, he put wheels on the shuttle and ran it across the baton that was used to push the weft home. At each end of the baton he placed a box with a metal peg or picker which could be jerked by means of a string that ran to the top of the loom to hang down in front of the weaver. The weaver could now move the shuttle with one hand while he used his other hand to swing the heavy baton to and fro. One man could weave cloth that had previously required the work of two; and the shuttle sped on its course far faster than under the old system. 'Production could be doubled,' proclaimed Kay, hoping to make his fortune. 'Half of us will be out of work,' replied the weavers, who proceeded to smash the looms. Kay left the country.

The flying shuttle, however, soon came into general use and now, with five spinners needed to keep one loom busy, demand for yarn grew. The only possible solution was to mechanise spinning. Britain began the move towards the factory age. The old was to be in conflict with the new. Was the future to lie with the craftsmen or the factory

The Lerry woollen mill at Talybont, Dyfed.

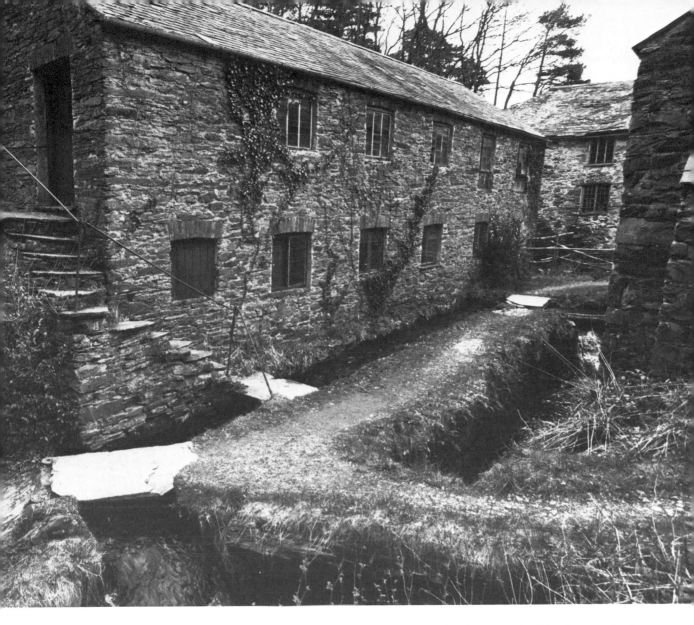

operatives? It was not, of course, quite that simple. The factory, in the sense of a building where a great many operatives were working together, was already in existence before the eighteenth century. In the sixteenth century there was a textile factory at Newbury in Berkshire, described in a poem by Thomas Deloney:

> Within one room being large and long
> There stood two hundred looms full strong.

Not quite a cottage industry, though there are important differences between that and the factories that were to come.

The coming of mechanisation did not put an immediate end to the craft tradition. At Talybont in Dyfed there is a working tweed mill where little has changed in a century and a half and which represents a kind of compromise between the old world and the new.

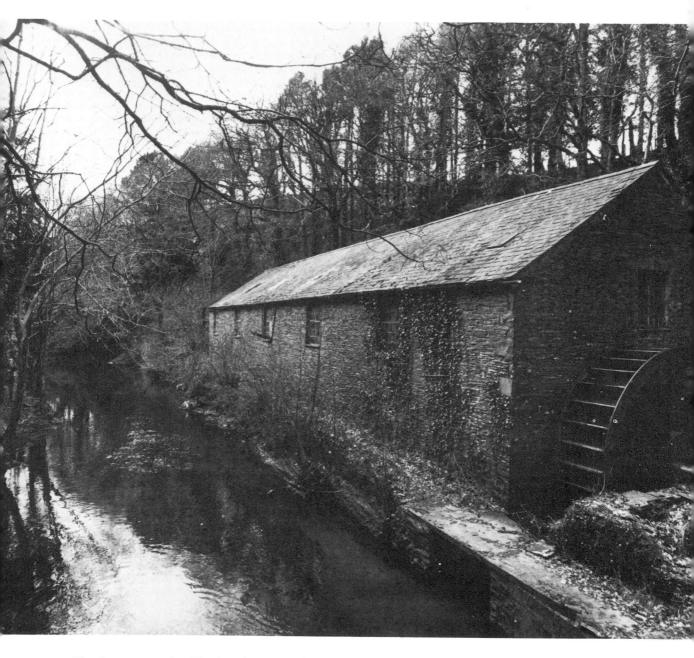

The Lerry tweed mill takes its name from the river which flows past the works, and like so many old industrial buildings these have seen a variety of uses over the years. In the 1560s, a smelting works was established here to deal with lead from the local mines. The site was then known as Caefelinfwyn – the land of the lead mill. But, by the end of the eighteenth century, the lead industry had come to an

The weaving shed at Lerry Mill with its undershot wheel at the end of the building.

end and the land was leased to David Morgan from Caersws who established a woollen mill.

Approaching the mill from the main road, you can see to the left a house with the mill shop attached. Look closely, and you can see that there are in fact divisions in the building which indicate that it was once a row of six cottages. These were occupied by weavers who worked the looms in their own homes. On the opposite side of the roadway are three buildings, grouped round a complex of leats which carry water from the river. Originally, each building had its own water wheel, but today only two survive. The building nearest the path and parallel with it was in fact the old smelter. The chimneys provide the evidence, but there is nothing else to distinguish it from the rest. All the buildings are in a simple vernacular style, with strong, rubble walls and rows of plain windows. Once you had a strong building and water power, then your building did as well for a cloth mill as it did for smelting.

This little complex made up a complete cloth production unit. Every process from carding up to and including fulling was carried out on site, but today the mill is almost entirely limited to weaving. Though the Hughes family, who own the mill, do a little spinning, they buy in most of their yarn, so it is the work of the loom that the visitors come to see. Leaving the first group of buildings, the path leads down through the woods to the single-storey weaving shed. Outside is an undershot wheel, built in 1828, that still powers machinery in the mill through shaft and belt drive. Inside, the weaving shed has changed little with the years. Here are the looms with their solid timber frames, that look as though they belong in a textile museum. Yet see master weaver John Hughes at his favourite loom and you soon realise that in spite of its apparent crudity, this is a very productive machine. The skill lies in coordination of hands and feet to produce a steady rhythm as the reeds rise and fall and the shuttle flies: it is rather like playing a church organ, producing cloth instead of music. It is hard work, constantly pushing and pulling the heavy wooden baton, and monotonous; but the hand loom weavers clung tenaciously to their craft. Partly it was conservatism, a reluctance to change out of the old ways; but, more importantly, the weaver saw himself as a craftsman, responsible for his own destiny. He was something more than a mere machine minder, and in the case of the cottage weaver, he had a degree of independence. He had so much work to complete within the week, but within those limits he could choose his own time in which to do it. The weaving sheds at Lerry Mill look back to that old tradition, but from their beginning they were also part of the new world of mechanisation that was to transform textile manufacture in the eighteenth century.

The major change did not begin in the traditional woollen industry, but with a newcomer to the British textile world – cotton. Cotton

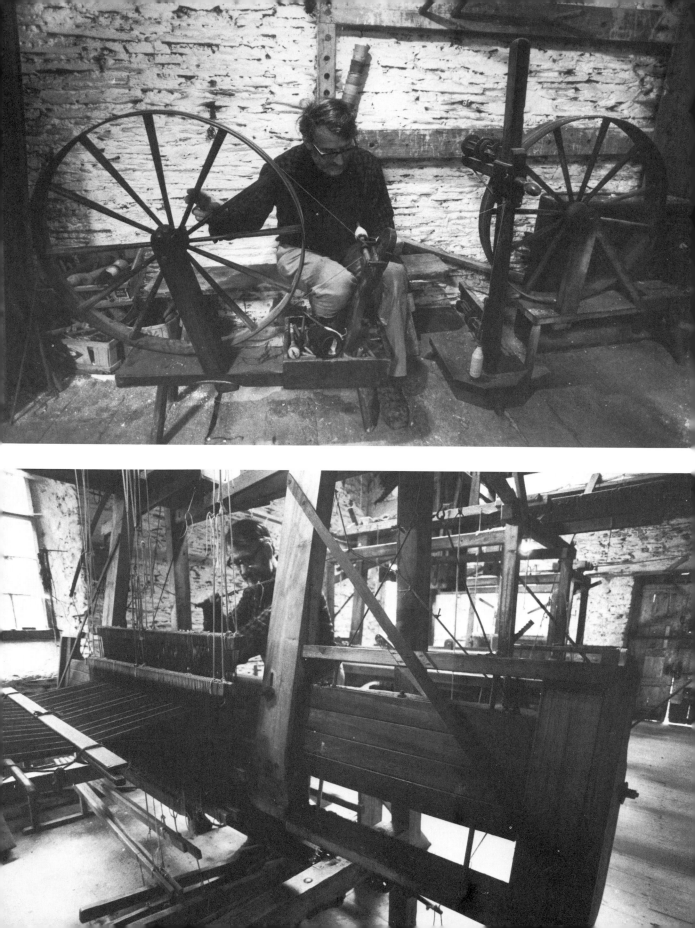

Above
*John Hughes winding the
wool on to a bobbin which will
be placed in a shuttle ready
for weaving.*

Below
*John Hughes at the loom. His
right hand pulls the cord that
works the flying shuttle, his left
hand swings the baton that
bangs the weft thread into place.*

goods had been brought in from the East by the new trading companies. At first there was an outcry against overseas competition and Parliament legislated against cotton imports in the early 1700s. They could not, however, legislate against fashion, and the demand for light, easily-cleaned cotton goods grew. British textile manufacturers, working on the old and well tried 'if you can't beat 'em, join 'em' principle decided that if cotton goods were wanted then it would be British manufacturers who would supply them. The problems of turning cotton wool into cotton yarn are not very different from those of treating sheep's wool. In mechanising those processes, yarn production was moved from home to factory.

The main inventions were simple and came in rapid succession. James Hargreaves, a Lancashire weaver, produced his spinning jenny somewhere around 1764. It was rather like a spinning wheel knocked over on its side, but turning a number of spindles instead of just one. It was worked by hand, and Hargreaves hoped, as Kay before him, to make his fortune. Instead he was also assailed on two sides: conservative spinners attacked his machines while ambitious spinners pirated the invention. In time, the jenny was accepted as the flying shuttle had been, as a means of improving the production of the cottage worker.

The inventions by Richard Arkwright of both the water frame and the carding engine were of a very different nature. The water frame owed its name to the source of power – no longer the human hand, but the water wheel. Cotton from the carding engine, which imitated the action of the hand carders by means of rollers studded with wires, was roughly twisted into what was known as a roving. It was then fed through rollers moving at different speeds which drew out the thread. This was then twisted by a flier and wound onto spindles. The construction of these machines was simple, well within the capabilities of millwrights, carpenters, clockmakers and similar craftsmen. From that point of view, there was no great break with tradition. But such machinery could have no place in the home: it required a special building, a mill or factory. The same was true of the other spinning machines of the eighteenth century such as Crompton's mule, so called because like a mule it was a hybrid, combining the best features of the water frame and the jenny.

The woollen industry was slow to adopt the new machines, partly because the earliest models were not as well suited to wool as they were to cotton. The changes from old machinery to new were not, in any case, always drastic. Lerry mill is, in many ways, like the mule, a hybrid, a cross between the old ways and the new. Here, in the other group of buildings, are carding engines and spinning machines, used alongside hand cards and hand looms. There have never been more than seventeen workers employed and, if all the changes in the textile industry had been no more dramatic than this,

then we should not be talking of any kind of revolution. There would have been no major social upheaval. But elsewhere things were very different.

Richard Arkwright was determined that he would not share the fate of his fellow inventors, Kay and Hargreaves. He wanted to make sure of his profits. With his partners, he made a successful trial of his machine and then set out to look for a suitable site to establish a mill. It had to meet two criteria: water had to be available to turn the machinery, and the mill had to be out of the way of both wreckers and pirates. He moved to Derbyshire and the tiny hamlet of Cromford, a safe distance from the major textile district of Lancashire. His mill was a success and Arkwright went on to make his fortune. However, the road to riches was not always straight. When he did attempt mill building in Lancashire, a wave of rioting spread through the country and the mill was burned, but the troubles soon abated and building began again. Arkwright had less success in keeping his invention to himself, and soon other manufacturers were pirating the invention. He brandished his patents, but the opposition stood firm. They challenged the patents in the courts and, in 1781, they were overthrown: Arkwright's monopoly was officially ended. It was a signal for a rush of mill building, especially in the north-west.

Of all the mills that were built and of all the villages that were built to serve them, none has retained more of its original character than Quarry Bank Mill, and its accompanying village of Styal, in Cheshire. Samuel Greg came here from Belfast in 1784 as one of the many manufacturers who rushed to take advantage of Arkwright's defeat. It was then a hamlet, no more than a couple of farms and a few cottages, but there was land for building, a river for power and it was on one of the main routes used by the Cheshire salt traders. A weir was built across the river, high enough to ensure a good build up of water behind it to supply the leat that led off to the mill site.

Standing by the weir looking out through the trees, one can see the distant mill, and the first thing that is immediately obvious is that this is an enterprise on a totally different scale from that of Talybont. The building is, by comparison, vast – four storeys with an attic. It cost £16,000 to build, yet this great building was not put up to hold all the processes of cloth making as at Lerry Mill, but simply to house machines that would spin yarn for others to use. These machines could spin cotton at a fraction of the cost of the older methods and in far greater quantities. The British mills were on their way to becoming the cotton workshop for the world.

Inside, Quarry Bank Mill has been stripped of all its old machinery. However, the machines are gradually being returned as the building is refurbished to take on a new role as a textile museum. Down in the basement is the wheel pit where two water wheels once turned. Later, these were replaced by a single 33-foot diameter over-

The industrial revolution comes to the textile industry: Quarry Bank Mill, Styal.

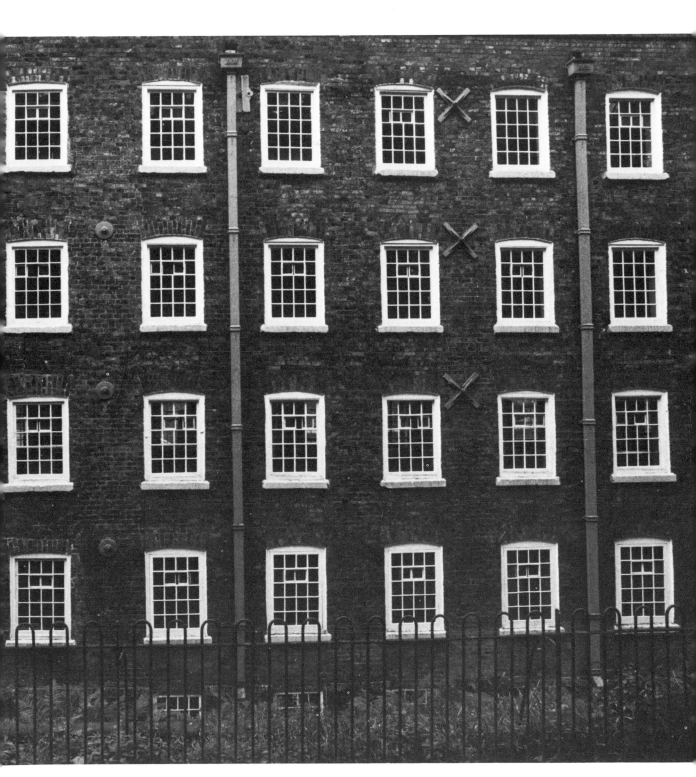

shot wheel. On the upper floors, the simplicity of the mill structure is apparent. The main requirement was uninterrupted space for the rows of water frames, powered by belts turned by the overhead shafts which, in turn, were geared to the water wheel. In 1790, there were 263 workers in this mill. With the old spinning wheel, there would have been one spindle for each working spinner. At Quarry Bank Mill, 4000 spindles turned.

The work of spinning had traditionally fallen to women, and the same was true in some measure at Quarry Bank. It was regarded as a model establishment. Greg provided, for example, crèches where the women could leave their babies while they worked. They were on balconies above the spinning rooms, so that mothers and children were in sight of each other. Was the life of the mill spinner very different then from that of the cottage spinner? Yes, it was. A clue to where the difference lay can be seen at the very top of the mill building – the clock and the factory bell in its little cupola. The new technology imposed a new social pattern. Once the sluices were opened

Samuel Greg's house next to the mill he built at Styal.

in the morning and the drive shafts began turning, the 4000 spindles had to be tended. A constant supply of rovings had to be fed into the water frames and the bobbins full of yarn had to be replaced by empty ones. The spinners no longer selected when to work the machines: the working of the machines now determined the work of the people.

Samuel Greg was the very model of the paternalistic employer. You can feel something of this when you walk into the mill office, dominated by portraits of members of the Greg family. He was also, of course, a man looking for a return on a large investment. He kept a close eye on all the comings and goings of the mill. His own attractive house was built next door, only separated from the works by a narrow pathway. But Greg had to provide more than just a house for himself, for the new work force also needed somewhere to live. Follow the road up the hill and you come to a red brick house, which might at first glance be taken for another grand family home. A closer look shows it to be in two parts: one part is a conventional house, the second part has more of an institutional air, with its tall windows

rather like those of an old style school. It is, in fact, the apprentices' house. The conventional part was home to the overseer and his family; the rest was for the hundred or more boys and girls who worked in the mill.

Another crucial factor in the changing face of the textile industry was the simplicity of the new machines. One skilled worker could oversee hundreds of spindles, though there were a number of simple, repetitious jobs that still had to be seen to – changing bobbins, repairing broken threads and the like. As machinery was expensive to install, the mill owner looked for economies elsewhere. He made them in the work force. Those simple jobs were given to children, many of them the apprentices who came to live in the house up the hill. They came from many parts of the country: some were orphans, some came from families who were too poor to support them and many came from the parish poor houses. They could start in the mill as young as nine years old and, as many old documents have survived, we know a good deal about their lives.

Apprentice indentures generally specified that the children were to work twelve hours a day, six days a week. Their pay was negligible – a penny a week – but they got a roof over their heads, clothes on their backs and food in their bellies. True they slept two to a bed, and the food was not exactly tempting – porridge, bread and milk, bacon and potatoes and each of these would constitute a main meal – but that has to be set against the conditions outside the apprentice house. This was far better than anything they would have found as village paupers. The mill closed on Sundays, when the children had church in the morning and school in the afternoon, after which they had the luxury of time to themselves. The Styal apprentices were very much luckier in this than their contemporaries in other mills. Here there were resident housekeepers whereas in other places the children were simply locked up for the night and left to their own devices. The Styal children worked long hours: others worked longer, kept to the task by frequent beatings. But even here, where conditions were said to be about the best in the country, the children suffered. Accidents among the unguarded machinery were commonplace and even if other places were worse, a working day that began at 6 am and ended at 7 pm must have been misery for a nine-year-old child far from home.

The apprentices represented only a proportion of the work force and as time went on that proportion was reduced. In 1831, there were 450 employees of whom only 100 were apprentices. The rest were made up of the families who came to live and work in Styal. For them Greg had to build a whole new village. Wages at Styal were low, but Greg did his recruiting among the poor of the surrounding districts. Parish overseers sent details of destitute families, and those families were more than delighted to find work and a decent home. Walk across the fields from the apprentice house and you can see the vil-

The bottle kilns at Gladstone Pottery.

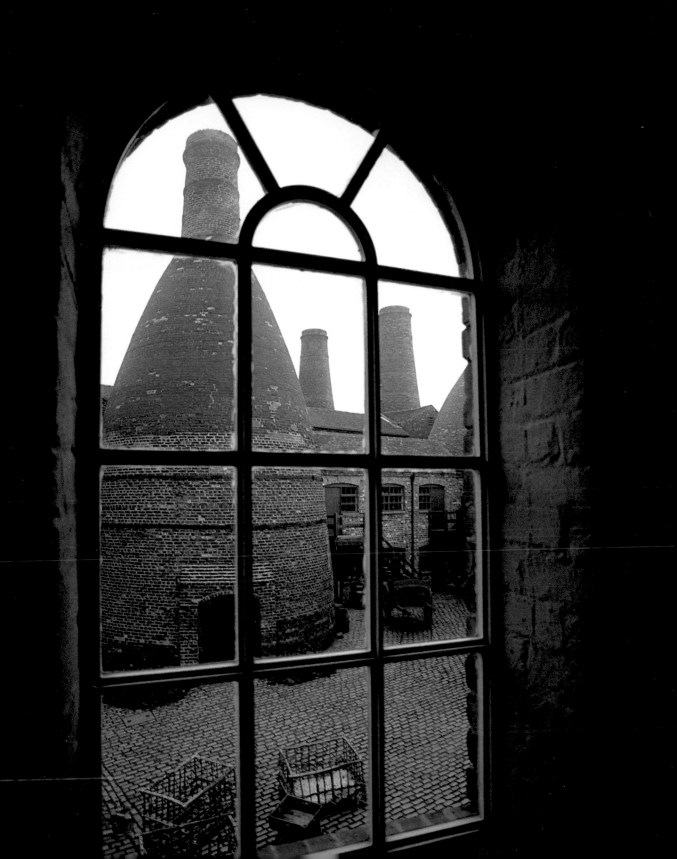

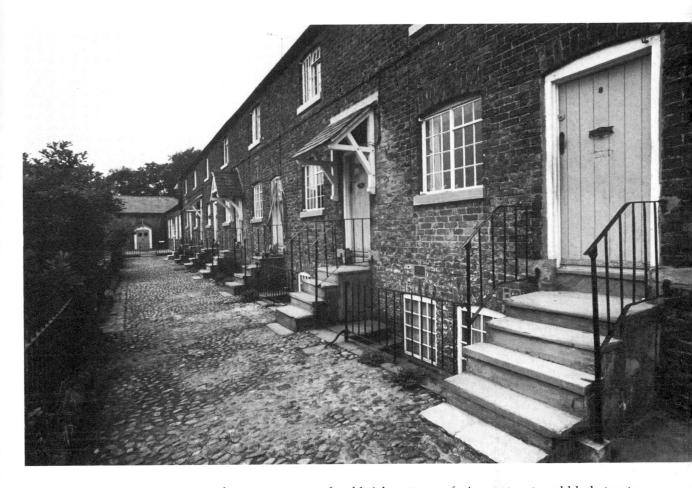

Above
The mill village at Styal. These cottages housed two families, one above ground and the other in the basement.

Left
Interior of a bottle kiln. The saggars holding the ware to be fired are stacked around the kiln wall.

lage, neat rows of red brick cottages, facing out onto cobbled streets. Each house has a feeling of airiness and light about it and each has its own back yard and privy. They were, and are, attractive. The houses in their country setting were so attractive in fact that cases have been recorded of families who went off to nearby Manchester, drawn by the prospect of higher wages, but soon came back to Styal again. The village cottages were so far preferable to the city slums, that they decided to settle for lower wages after all.

In the village are church and chapel, school and, very importantly, the shop. This was run by Greg and most goods were bought on credit, the value being deducted from the family wage packet at the end of the week. It was a system very open to abuse: the workers, paid in arrears, had little option over where they shopped, and the unscrupulous mill owner could take whatever profit he chose. That does not appear to have been the case here. The system does, however, have one great advantage for the historian. Wage bills were compiled, annotated with details of what had been bought at the

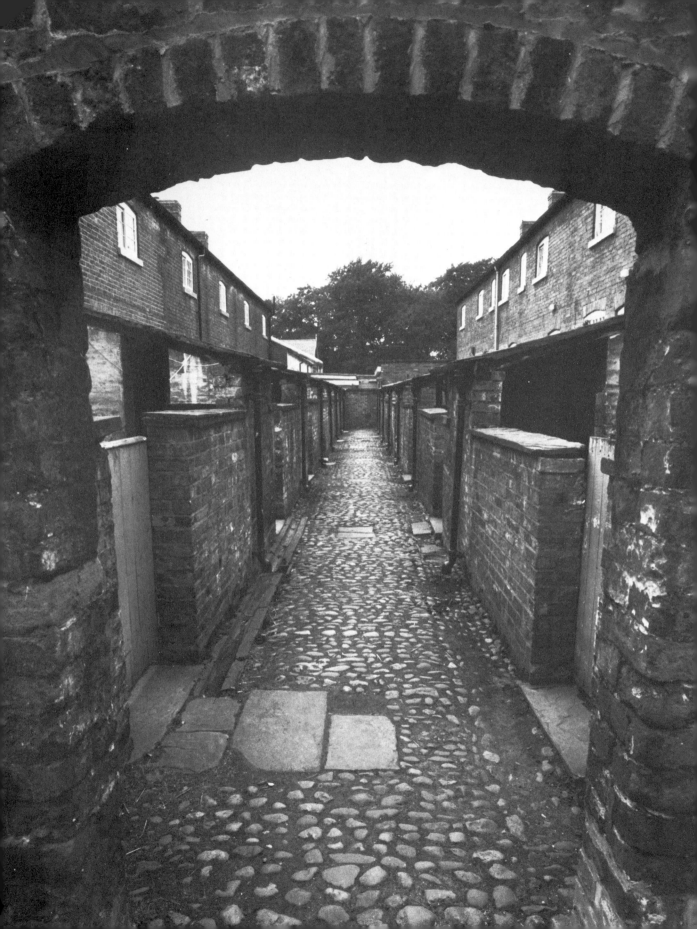

Samuel Greg had his own shop to supply the mill workers.

Left
The Styal cottages had amenities which were modern at their time, such as the privies in the back yards.

shop, and this gives a good idea of the standard of living of the workers. There was little or no room for luxuries. Most of the cash went on a few basics – flour, bacon, cheese, potatoes and skimmed milk, though some operatives who were better off could occasionally enjoy fresh milk, butter and even a little meat. It is interesting to see that the food bought by the families is much the same as that given to the apprentices.

A walk round the village of Styal reinforces the picture of a comfortable, if not very prosperous, community. This community, however, was not static: there were slumps as well as boom periods. Nor was the world of the mill unchanging. There were two major developments, both of which left their marks on the mill buildings. The regular façade was broken by the erection of a tall chimney that indicates the arrival of a steam engine to supplement the power of the water wheel. It was only a small engine that was brought in 1800, a mere 10 HP, but its arrival was a sign of what was going on in other parts of the country. Throughout the nineteenth century, steam power came to replace the water wheels. It had obvious advantages.

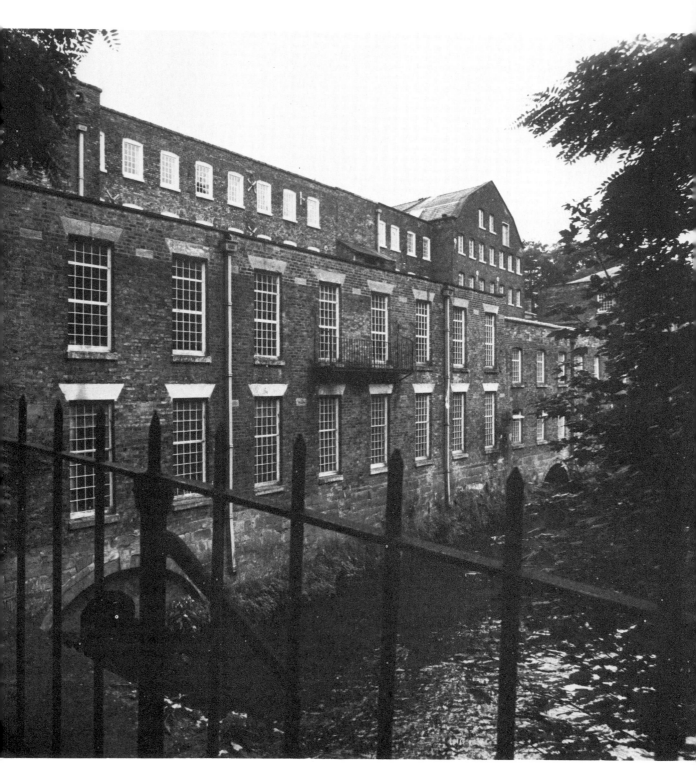

In the 1830s weaving sheds containing power looms were built on to the back of Quarry Bank Mill.

The steam engine could be kept going during periods of drought that would have brought the old water wheel to a halt. More importantly, for owners planning new mills, buildings no longer had to be set by the side of a river. The owner could move into the centre of town, conveniently close to all the facilities he might need and close to the major transport routes. The second change came about after Samuel Greg's death in 1834. He had always insisted that his was a spinning concern, and if there was any weaving to be done it should go to the local handloom weavers. But, in 1835, his sons bowed to economic necessity and brought the looms to the mill. A long row of weaving sheds was added at the back of the mill, not to take handlooms but the new power looms.

The first power loom had been built as early as 1784 by a clergyman, Edmund Cartwright. It was a remarkable piece of work for Cartwright had, it seems, very little idea of how an ordinary loom worked when he started building the first powered one. The best that could be said for the prototype was that it worked, for it was hopelessly clumsy and the various movements were harsh and violent. But once the thing had been shown to be possible, improvements soon followed and by the early 1800s power looms were common. The manufacturer now had the means to move all the different processes into his mill, and he could dispense entirely with the old-style craftsmen of the textile industry. The new machines were cheaper, quicker and far more productive. Such changes made little difference to life in a backwater such as Styal, but in other places the changes were dramatic and far-reaching.

No one museum could show what these changes meant to the textile districts of Lancashire and Yorkshire. Yet go through the region and you can see the evidence on every hand – Blackburn, Oldham, Bradford, Huddersfield and the rest. Even so, much of it has already changed again. Mills are closed and many have been demolished – in fact, while working on the television series we originally selected a site in Rochdale only to find between two visits that our mill had vanished! Similarly, the rows of back-to-backs have been bulldozed to make way for new homes. Few mourn the passing of the old mills and their clustering terraces, but anyone who wants to understand what textiles meant to the industrial life of the country should see what is left before it, too, disappears. There are a number of places you could choose, but nowhere can the contrast between the old world and the factory world be seen in more dramatic conjunction than in the Colne Valley.

Go back to Golcar. This time, instead of looking up at the old hilltop village with its attractive weavers' cottages, look down at the valley floor and you can see just what progress has meant. The Huddersfield Canal can be seen as a thin, silvery thread leading on into the centre of Huddersfield itself. On either side of the canal, the mills cluster. This was just the sort of site the mill builder was looking for,

with a canal on the doorstep to bring in the coal for his new steam engine and close to the main road. So the valley bottom was filled with the tall spinning mills and the long, low lines of the weaving sheds. In and around the mills are the terraces that were home to the new generation of factory workers. This was the new world: urban instead of rural, factory instead of cottage. In 1826 the hand loom weavers made their last stand for the old order, marching down through Lancashire, smashing power looms wherever they found them. It was hopeless: the logic of progress was against them. The factory age would, in the long term, bring a prosperity that they would never have dreamed possible. Even so, it is not easy to dismiss the emotional case. How many of us would willingly exchange a stone built cottage with a view over the moors or even a Styal for a terrace where the view is a factory wall and the air is heavy with smoke? Industry brought its benefits, but a price had to be paid.

Steam power produced the typical landscape of the Victorian mill town: the Colne valley looking towards Huddersfield.

94

To Make a Teacup

The ceramic industry saw none of the dramatic new inventions in the eighteenth century that were such a feature in the world of textiles. There were changes, but these were not so directly tied to a single event, such as the construction of a new machine. Yet the transformations in the industry were real enough and, to the working potter, they must have seemed revolutionary. The craftsman who could turn his hand to all parts of the trade began to disappear as the pot works were reorganised into something that was recognisable as a production line. Instead of one man working his way through a series of processes to produce the finished ware, the processes were isolated and specialist workmen allocated to each step. It was the change from the methods of a medieval craft to those of the modern world.

Some of the first and most notable innovations involved the raw materials for the industry. The Staffordshire potteries grew up around the Stoke area because the region had both good clay for earthenware and good coal for the kilns. The rough, homely pots which are a delight to the modern eye were not, however, quite so pleasing to Georgian taste. They wanted delicacy in both form and colour. Common red clay covered with a thick white glaze was not good enough. The problem was how to produce a white body that did not need such a thick covering. Credit for finding the answer is generally given to John Astbury who, in 1720, added ground flint to the clay, whitening the body. The popular version of the discovery has Astbury stopping at Dunstable with a temporarily blinded horse. A local ostler cured the blindness by blowing powdered flint into the horse's eye. The animal was cured and Astbury was struck by the whiteness of the flint. The story sounds about as likely as the cure and, in any case, there is evidence to suggest that flint was in use before the end of the seventeenth century. The crucial point is that the addition of flint did the trick, and a new industrial building began to appear on the Staffordshire scene – the flint mill. At first the flints were ground dry, producing a fine dust which was literally lethal to the grinders. Then, in 1726, Thomas Benson patented a method for wet grinding and a mill complex, based on his method, has survived virtually intact at Cheddleton, near Leek.

The first step was to calcine the flints, heating them in kilns to make them brittle and easier to crush. At Cheddleton, the flints were brought to the mill by water and unloaded onto a wharf which had the kilns built directly into it. Flints and coal were fed directly into the top of the kiln and, after heating, the calcined flints were shovelled out at the bottom and loaded into trucks. Like so many early industrial sites, Cheddleton looks very attractive and picturesque, purpose-built for the picture postcard trade, but behind that rather old-fashioned beauty lies some sophisticated planning. Everything is arranged to save labour, and a good deal of thought went into the details of construction. The stairway leading down beside the wharf is a good example.

The wharf at Cheddleton. Flints were unloaded straight into the kilns where they were heated to make them more friable.

Instead of building a separate flight of steps, the builders simply left some of the large stones of the wharf protruding out: neat, cheap and satisfactory.

From the kiln, the trucks were wheeled on a plateway to one or other of the two mill buildings. The origin of these buildings is uncertain. There have been mills on this site since the thirteenth century and certainly the first of the two buildings, the south mill, began life as that most adaptable and adapted of structures, a water-powered corn mill. Both mills, however, are very similar and were adapted to flint grinding, reaching their present form around the 1780s.

A leat from the River Churnet divides to turn breast shot wheels on each mill. The two mills perform the same functions, though with minor variations. Basically, a vertical gear wheel turning directly on the shaft of the water wheel engages with a horizontal gear wheel set on a vertical shaft. This system of pit wheel and wallower engaging to turn a vertical shaft is the normal mechanism of the grain mill. This shaft passes up through the first floor, emerging in a circular tub, or pan, lined with chert, a hard stone. Blocks of chert are fastened to wooden sweep arms on the rotating shaft. Flints were brought in from the plateway and hoisted up to the first floor to be loaded into the pan. Water was then pumped up, in the case of the south mill, by means of a beam pump. As much as a ton and a half of calcined flint would be put in as one load and then, when the water had been added, the heavy cherts would begin to revolve, commencing the long, slow process of grinding. After about 24 hours, the mixture in the pan was a thick, white liquid rather like cream.

Above
From the kiln the flints were taken to the mill.

Right
The water wheels that supply the power at Cheddleton.

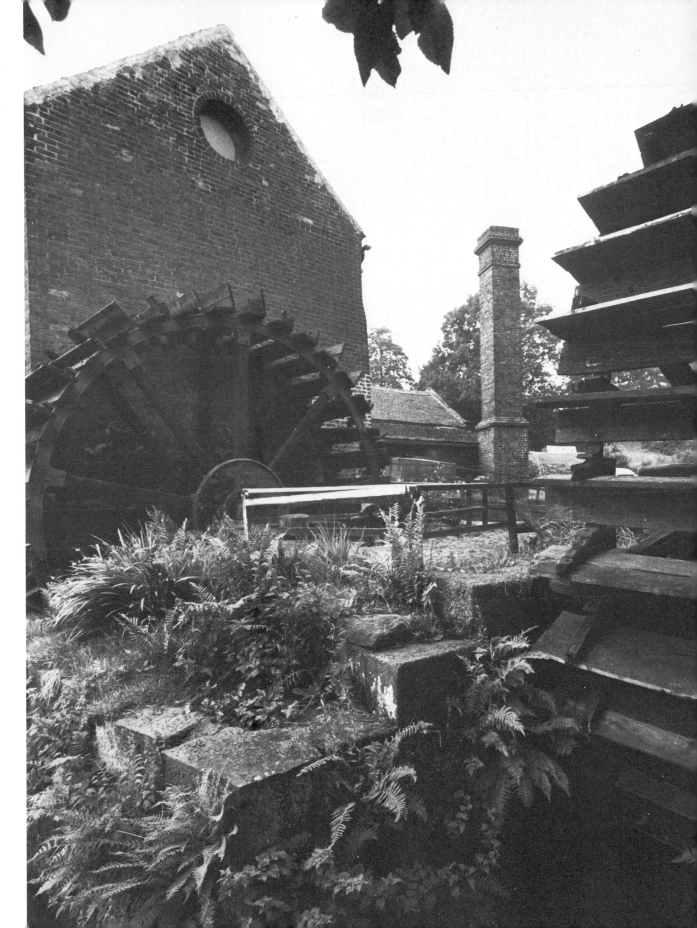

The creamy mixture was now run off into a washtub, where more water was added, and thoroughly mixed with wooden paddles. Any coarse flint was separated off and returned to the pan for extra grinding. The rest was again drained downwards into the settling ark. This is rather like a big bath tub with a series of plugs up the side. As the flint settled, so the water at the top became clear. Plugs were gradually removed, draining off the clear water, until the thick slurry or slop was reached. This was then pumped into a drying kiln, where the last of the water was evaporated off. Originally this would have been done in a sun pan which, as the name suggests, simply used the open air and sunshine to do the drying. The more efficient slip kiln was built around 1830. The slop was pumped onto a stone pavement, under which passed flues carrying hot air from the furnace.

This is the flint mill at its simplest. Steam power replaced water power in later mills. Cheddleton kept to the old methods, but they do have a steam engine on display which was used for the flint mill of Minton's at Stoke. The mill buildings also house other grinding machines. There are stamps which pounded the flint and an edge-roller, in effect a pair of mill stones in which the upper stone is mounted vertically and rolls over the lower like a wheel. This was used for preparing other basic materials, such as glazes and colourings.

One of the great satisfactions of visiting a site such as Cheddleton comes from seeing the combination of mechanical simplicity with sophisticated planning. No expert knowledge is needed to 'read' the working of the machinery. It is also easy to appreciate the care that

The mill buildings, much altered over the years – an extra storey was added to the building on the left during the eighteenth century.

The grinding pan: the flints were crushed by the heavy stones attached to the rotating sweep arms.

went into the organisation. This was almost certainly due in part to James Brindley who was a millwright for many years before he achieved fame as a canal engineer. The arrangement allows for the minimum of pumping and the maximum use of that useful force, gravity. It is difficult to see how the robust machinery at Cheddleton could have been better used.

Flints were introduced into the pottery industry at the beginning of the eighteenth century: the use of kaolin or china clay to manufacture porcelain or fragile china came rather later. The manufacture of porcelain did come into Europe from the Far East quite early, but was slow to reach Britain. The earliest porcelain works were at Meissen, near Dresden, and at Sèvres in France. In this country, the discovery that porcelain could be produced from kaolin was made by a Plymouth chemist, William Cookworthy, who took out a patent in 1768. Like many other inventors, Cookworthy had the technical ability but lacked the business nous. He sold out to Richard Champion who, in turn, sold out to Staffordshire. China clay – so called because it could be used to produce pots in the Chinese manner – soon became one of the important raw materials for the potteries.

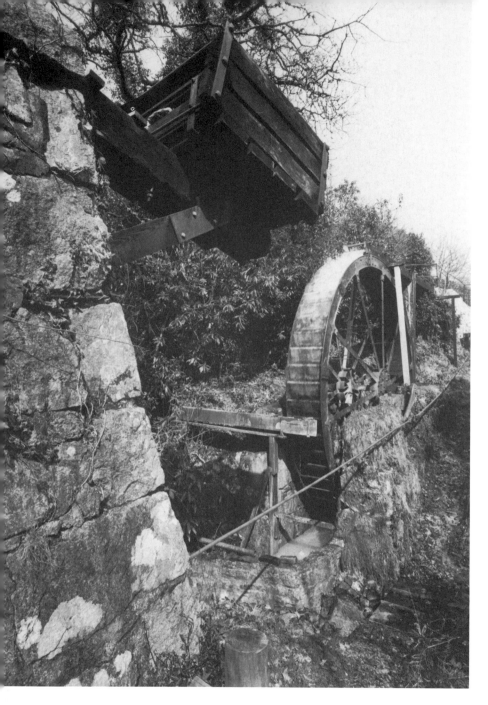

In Britain, the bulk of china clay comes from a region centred on
St Austell in Cornwall. The industry has left an indelible mark on this
corner of Britain. If you look at the 1:50,000 os map of the area, you
can see that the clay region is set within quite distinct bounds. Draw a
line north from St Austell for about eight miles and sweep it round in
an arc to the west and you will have enclosed virtually the whole
area. On the map it appears as a series of hills and lakes which, on the
ground, become pits and spoil heaps. Some find it ugly, others see a
kind of surrealist beauty in the strange, white land. It is a landscape
that owes a little to nature and a lot to man's interference with it.

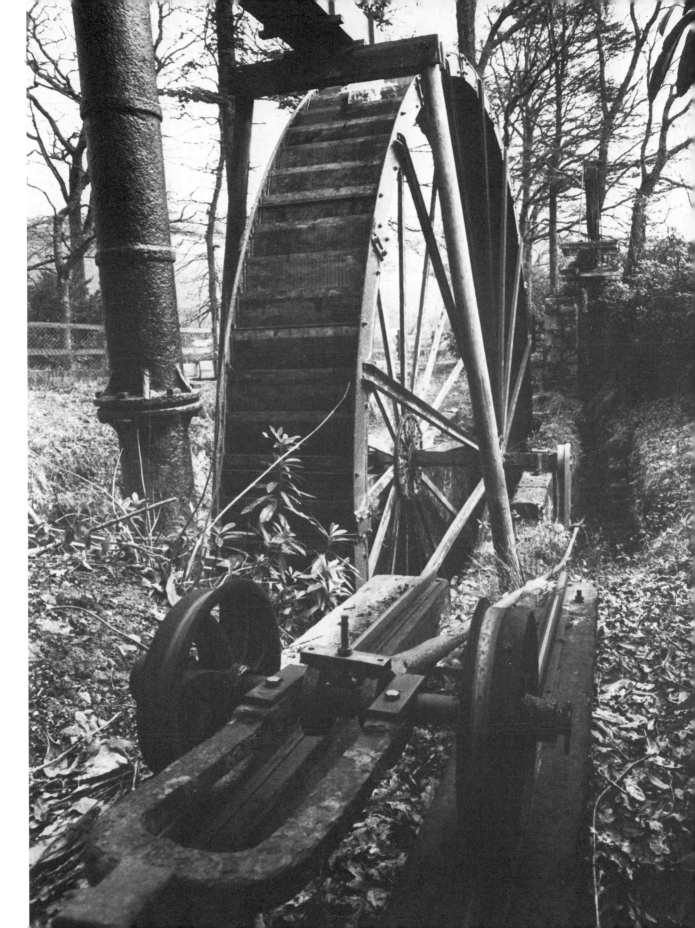

It is still a thriving industry, for china clay has found many new uses. Inevitably, methods of extraction have changed, and many of the old workings have been swallowed up by the new. The Wheal Martyn museum is based on old works which have been restored to show the working techniques of the past century.

Kaolin is partially decomposed granite and it is extracted by being washed out of a pit with water. The impurities, mainly mica and quartz, are removed and the pure kaolin dried. To obtain a little kaolin, however, a great deal of rubbish has to be removed: the ratios are roughly eight tons of quartz sand for every ton of clay. All that rubbish has piled up over the years in high white cones, visible for miles – the 'Cornish Alps'. Long before you get anywhere near the actual works, the china clay industry has announced its presence.

To get at the china clay, the overburden, the rock and soil that lie above the clay, has to be removed. Only then can the kaolin be washed out. In the simplest method, the pit was dug in the hillside and a stream diverted to wash the clay down, which is no more than a

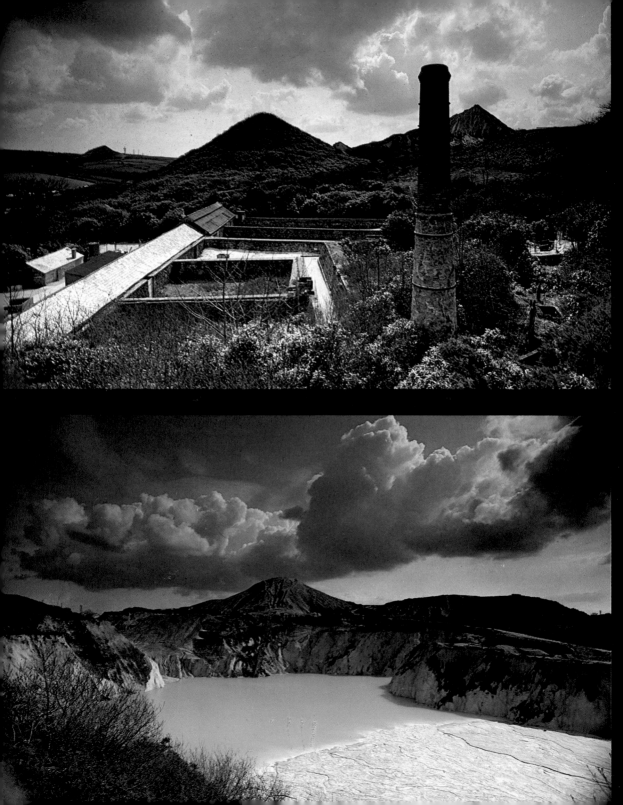

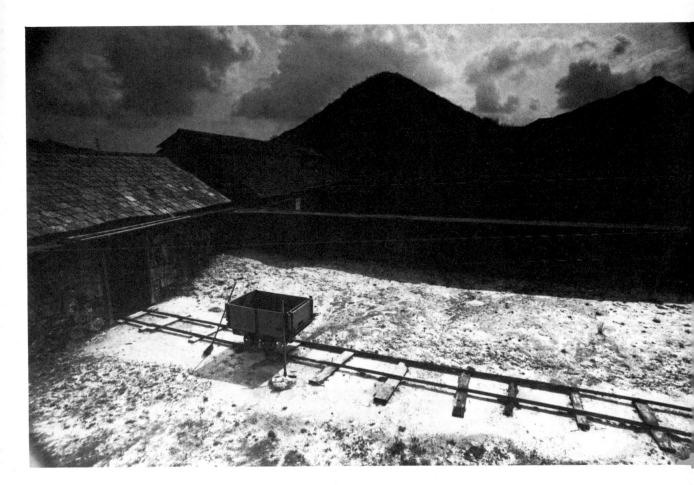

Above
The drying tanks at Wheal Martyn with the huge hills of spoil from the works behind them.

Above left
Wheal Martyn, the old china clay works, now a museum.

Below left
The weird, unearthly landscape of spoil heaps and ponds produced by the china clay industry.

version of the 'hushing' technique used by the Romans over a thousand years earlier. This method had a very limited life and soon the normal technique was to dig a pit and remove the kaolin as a pumped slurry. Water wheels powered the early pumps, but later the steam engine took over. The slurry was brought up from the bottom of the pit via a device known as a rise and button launder. First a shaft was sunk down from a spot somewhere near to the edge of the pit and to a depth below the pit bottom. Then a level was dug across under the pit – no simple task in wet, sliding clay – and a second shaft dug up to the pit bottom. This was the rise which held the button-hole launder, a wooden pipe with plugged holes in it. The top hole was uncovered so that the slurry would pass in and, as the pit bottom sank, so more holes were unplugged. The first shaft contained a simple plunger pump that lifted the slurry to the surface.

Entering the Wheal Martyn museum site, the first thing you see is the 35-foot diameter pitch back wheel which once worked the pump at the pit. Such wheels could be very efficient, which accounts for the

107

Left and right
Drying tank at Wheal Martyn: the thickened clay was loaded into trucks and wheeled into the 'dry', a vast kiln in which hot gases passed under the floor.

great length of time this one remained in use. It powered the pump here right up to the pit closure in 1930 and for ten years after that it was used to keep water from the pit in the hope that one day it might reopen. It was not always possible to put wheel and pump very close together: in this case they were separated by nearly a mile. The connection between the two had to be made by a series of flat rods, attached to the wheel through a crank. As the wheel turned, the flat metal rods were pushed backwards and forwards. In their long journey, the busily oscillating rods passed over settling beds and through specially constructed tunnels.

Ideally, once the slurry was pumped from the pit, gravity could take over the work of moving it through the next processes. Unfortunately Wheal Martyn has an awkward, hilly site which made a long, downhill run impossible. So an extra pump had to be installed to

move the slurry. Again the power came from the water wheel, this time an 18-foot diameter overshot wheel. It was fitted with a crank from which a cable led up the hill to the pump. The wire had to be kept in tension, so some sort of opposing force was needed that would work in the opposite direction. This was provided by a balance which was simply a box full of stones and rubbish, the lifting of which provided work for the cable. It performed no other useful function whatsoever.

The process of cleaning the kaolin began in the pit itself, where the slurry was passed through a sand trap in which the coarse particles separate out. It then passed into the launder. Every so often the sand was dug out and carted away – and the conical spoil heap grew by a few more inches. The process of cleaning continued, with the slurry being pumped through a series of settling tanks in which the rest of the sand and mica were removed. The rate of flow of the slurry was critical and was controlled by workmen lifting and closing hinged flaps. Pure clay slurry then flowed to the blueing house, passing first through a filter which was kept clear by a heatherbrush turned by a little water wheel. It may sound an unlikely device, but it worked very well. The blueing house was so called because it was here that Reckitt's blue could be added to get rid of stains caused by iron ore. The water in the slurry was gradually run off in settling tanks, until an almost solid mixture was left which could be shovelled up and loaded into trucks. This sounds simple enough, but involved a pro-

digious amount of hard, physical labour. A railed track was pushed out into the tank and the men set to work to clear out something like 250 tons of heavy, glutinous clay by hand. As soon as they had reached the end of that, the next tank was ready and waiting.

Now the clay was dried in shallow tubs in the open air until it was solid enough to be cut into blocks. Any sand or mica remaining would be stuck at the bottom of the blocks and was removed by bal maidens – a charming name for a less charming job. The women had to lift the heavy, wet clay blocks and scrape them until every trace of dirt was gone. In the 1840s, the open-air drying was replaced by drying in coal-fired kilns.

The end of the journey, as far as the mine itself was concerned, was the linhay, or clay warehouse, where the kaolin was packed into wooden casks ready for loading into waggons. Most of it went off to the local port of Charlestown, still in use and still bearing the marks of the trade in the white-stained wharf walls. The same port did a busy trade in Baltic timber, brought in for the coopers who clustered round St Austell providing the casks for the various clay works.

China clay from Cornwall, flints from East Anglia, local clays, coal – all met up at the pottery. Yet, in spite of this new complexity among the ingredients of pot production, the basis of manufacture was the same in the nineteenth-century works as it had been for the medieval craft potter. You start with the raw material, clay. First it has to be mixed to the right consistency, then wedged. The clay comes in blocks which are sliced in half, after which one half is picked up and slammed down onto the other. The process is repeated over and over again. The object is to get rid of any little air bubbles that might cause the pot to crack in the firing. Then the clay is shaped into cup, saucer, ornament or whatever. It could be shaped by hand, pressed into moulds or turned on the potter's wheel. The latter process is one of those which seem simplicity itself when carried out by an expert. The turntable rotates; the lump of clay is moulded between the hands, rising up to take the form the potter requires. But, as anyone who has tried it will testify, the lump of wet clay can just as easily turn into an uncontrollably wobbling monster. Assuming, however, that some-thing useful is produced, the object is left to dry, after which it is stacked in a kiln to be heated to a high temperature until it is hard. At this stage, the pottery is known as 'biscuit'. After this first firing, the pot can be decorated and glazed. Glazing is no more than coating the pot with a substance which, after firing, becomes glass-like, and the pottery glaze is, in fact, a close cousin to glass proper. It has a practi-cal purpose: it makes porous pots watertight. It also has a purely decorative function. The glaze can, itself, be colourful; or it can be painted. Alternatively, the pot can be decorated, and a transparent glaze added afterwards. It is all a question of taste. Unlike the other

industries we have looked at, the pottery industry is as preoccupied with taste and aesthetics as it is with purely practical matters. In fact, many technical advances have been made because fashion demanded a certain type of ware, and to satisfy that taste is as much the concern of the factory as it is of the craft potter.

The processes used to achieve the end product are the same in craft pottery and factory but there is a vast difference in the way they are organised. The nineteenth-century pot works used a manufacturing system that, in its essentials, was laid down by Josiah Wedgwood in the previous century. This too has been overtaken by more recent developments, but one nineteenth-century pot works has been preserved which shows the old method of work. It is typical of the many works that could once have been found in the six towns that together make up The Potteries.

Gladstone Pottery is a medium-sized works established around the middle of the nineteenth century. It stands beside the Uttoxeter Road in Longton, and very little effort has been made to put on an attractive face for the outside world. The main entrance is via a tunnel through the façade, wide enough to allow carts to get into the cobbled yard beyond. This type of layout is typical of the potteries as a whole. Over the entrance is the manager's office, which provides the occupant with a good view of everything – and everyone – that comes into and goes out of the works. Behind the façade, the buildings seem to follow neither plan nor reason: roof lines waver and change, buildings meet at odd angles and the tall bottle ovens loom over everything. In fact, there is an underlying order beneath the apparent chaos. The plan cannot be strictly regular, because so many different processes with so many variations have to be contained within the factory walls. Different types of ware all demand different treatments.

The yard is both starting and finishing point for all the pot making processes. Here raw materials are brought and stored, and the finished ware kept in crates waiting for despatch. So a journey round the works starts here with the collection of ingredients. Even an apparently simple substance such as earthenware might include ball clay from Devon, local clay, china clay and flints. These have to be carefully mixed in the correct proportions. One of Josiah Wedgwood's major contributions to the world of pottery was his replacement of the old method of mixing, which depended on the judgement and experience of the individual craftsmen, with one in which the ingredients and their proportions were firmly fixed, determined by careful experiments. In other words, he brought scientific method into the work – and took away some of the individuality. Mixing at Gladstone was done in the slip house by the blunger, a machine in which clay and water were stirred by rotating blades turned by a small steam engine. The same engine was used to drive other machines in the works.

The very fluid clay and water mixture, known as slip, was sieved and dried in kilns, after which it was ready for wedging. In the early nineteenth century, this was one of the jobs that fell to young boys who had the hard and wearying job of lifting and throwing the heavy clay pieces, time and time again. Some of the clay was kept fairly liquid for use in moulds, while some was allowed to become quite firm for turning on the wheel or lathe. The easiest way to understand the subsequent processes is to see what is involved in producing such everyday objects as teacup and saucer.

The different workshops in which the cup and saucer would have taken shape are all clustered round the courtyard on the ground floor. This was essentially a mass production technique, but before that could begin, a prototype had to be produced, and here the skill of the craftsman at the potter's wheel was still called into play. Once the master potter had produced an acceptable design, then plaster moulds could be made and an endless number of copies produced.

Gladstone Pottery in 1973, before renovation. The saggar maker's shop stands next to the bottle oven.

The modelling and mould-making shops were on the upper floor, out of the way of the main production line.

To make a cup from the mould, the simplest method was to pour slip into the mould and then, after a turn or two, empty it out, leaving a layer behind that would set to the shape of the mould. It was then passed on to another department for the handles to be added by workers known as stoukers who specialised in this one job. Saucer making was rather different. The potter would take a pancake of clay in one hand. With his other hand he would spin the mould and press the damp clay into it. Such a brief description makes it sound both simple and undemanding work, but it was neither. Considerable skill was required to work at speed and there was a good deal of hard work, much of which fell at one time to the young lads who helped in the shop. Their job was to take the shaped saucers, known as muffins, and run with them to the stove room where they were set out on shelves to dry. The temperature in the room was very high, and running up and down steps to place the muffins on the higher shelves was exhausting.

The cup and saucer were, after drying, ready for the kiln. The ware had to be protected from the direct flames of the furnace, so it was packed into special fireclay boxes known as saggars. All the ware was collected in a small room by the kiln and behind that was the workshop where the saggars were made. They were shaped in an iron frame. First clay was pushed into the bottom of the frame and banged down firmly – a job that went to the now almost legendary saggar maker's bottom knocker. After that, the sides were built up round a wooden mould.

When there was enough ware ready stacked into saggars it was taken to the so called 'biscuit' kiln for the first firing. At Gladstone, the kilns are of the old type, known as bottle ovens. In their day, these tall ovens were the most distinctive feature of the potteries' skyline. In the days when there were literally hundreds of them in the area, few people took much notice, except perhaps to complain about the thick smoke they belched out over the town. Now that the bottle ovens have almost vanished we can look at them with fresh eyes, and appreciate the beauty of these gently curving towers. Inside, the effect is even more dramatic: as the builder of the Pantheon in Rome knew, there is no more theatrical form of lighting than that from a single, overhead opening. In this case the effect is incidental. The kiln is little more than a giant chimney. In the centre is a coal-fired furnace, around which the saggars were stacked; hence the shape, which allows space for the saggars while the narrowing at the neck helps to ensure a draught to the fire. The beauty of the kiln is no less real, however, just because it derives from necessity.

Once a kiln was full, the firing began. It was a slow process, requiring days rather than hours. First there was the slow build-up of

heat, then a long firing, followed by an even longer cooling down period. Kiln temperatures were critical. In the early days of the industry there were no suitable high temperature thermometers and everything depended on the skill of the fireman. At the end of the process the cup and saucer emerged as unglazed biscuit ware, ready for decoration and glazing. There were a number of alternatives available. It could be painted, in which case it would be sent up to the special paint shops, high up at the front of the building. Good, even light was required for this delicate work, so the shops were lit by overhead windows. It could then come back for glazing. Alternatively, the glaze could be added first. Many of the early glazes had a high lead content, and the workmen who had the job of dipping the biscuit into the liquid glaze frequently suffered from lead poisoning. The cause of the illness was well known but employers took the view that lead was necessary, so there was nothing to do but accept fate. After dipping, the ware was refired in the glost oven. A popular form of overlgaze decoration in the eighteenth century was transfer printing. The process is very similar to the one children still use to stick transfers on their hands and arms. If something really grand was required, the cup and saucer could be gilded, which would mean an extra firing, in the slender little enamelling kiln.

The pottery industry in the nineteenth century had a multitude of different methods and processes available, each process the responsibility of a specialist worker. The factory had to be organised so that process followed process in a smooth flow, ending when the ware was finally packed into crates in the yard ready to be sent on their way. A few choice pieces were taken to the front offices and set up on display to impress visiting buyers who could not be expected to wade through the slimy clay of the yard. The craft had become a mass production industry.

The other major change which affected the potteries during the industrial revolution was the move from total reliance on local materials to the use of materials brought in over long distances. Once, so tradition has it, the potters of Staffordshire were not above digging up clay from the roadway outside the works if they found themselves a little short. But there were no local flints available for Cheddleton mill; kaolin could only be had in Cornwall. The isolation of The Potteries was ending. It was ending in another way, too. The ware that was being produced was no longer aimed solely at a local market. It was being exported to Europe and America. But The Potteries are situated in the very heart of England, far from the ports. In the eighteenth century, roads were atrocious; river navigations nonexistent in the region. The Potteries had to be served by a new transport system, the system that for more than half a century was to carry the bulk goods of the new industrial age – the canals.

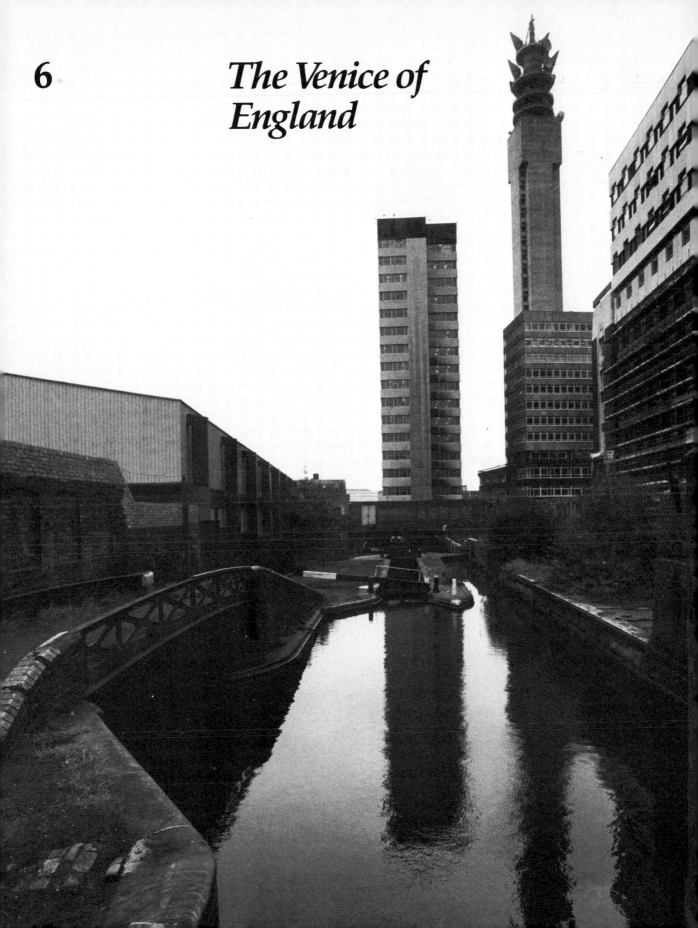

6 *The Venice of England*

The canal age proper began in 1761 when the canal financed by the Duke of Bridgewater to take coal from his mines at Worsley to the centre of Manchester was opened. It had at least one feature which was to mark most of the successful canals that followed. In the Duke's own words 'it had coal at the heel of it'. Coal was precisely the sort of bulk cargo that canals could best handle. It also boasted one feature which was an innovation for Britain, an aqueduct that carried the waterway high above the River Irwell at Barton. The insular British engineers mocked the whole idea of an aqueduct, quite ignoring the fact that three such structures had already been built on the Languedoc Canal in France, which was opened in 1681. The major feature of the Bridgewater Canal was, however, less spectacular if of far greater importance.

Large scale water transport schemes in Britain did not begin in 1761. Improvements in river navigations had been continuing for centuries. Many previously unnavigable waterways had been opened up by the building of locks and long artificial cuts to overcome rapids and shallows. Indeed, the main reason that the Duke of Bridgewater ever got into the canal business in the first place had nothing whatsoever to do with any desire to be a pioneer and innovator, but was a desperation measure forced on him by his inability to get his coal moved by the old Mersey and Irwell Navigation Company. The one unique factor that distinguished the Bridgewater Canal was that it was completely artificial, taking a line that was quite independent of any natural waterway. It was this ability to strike out across country that made it possible for the eighteenth-century engineers to bring water transport to the industrial heartland – to The Potteries, the Black Country and the rapidly developing centre of Birmingham.

In a sense, much of the canal system that survives today is the working museum of the canal age. Commercial freight traffic has long vanished from much of the system to be replaced by a new trade in holidaymakers. Each canal has its own characteristics, and many have unique and fascinating structures: the staircase of five interconnecting locks at Bingley on the Leeds and Liverpool, the flight of thirty locks spread out in a daunting row at Tardebigge on the Worcester and Birmingham, the 5456-yard tunnel at Standedge on the Huddersfield Narrow Canal and, most famous and spectacular of all, the 127-foot high aqueduct that carries the Ellesmere Canal across the River Dee, the Pont Cysyllte. But, for anyone wanting to see the whole range of developments from the beginning in the 1760s to the end of the period when engineers turned away from canals and towards railways in the 1830s, then there is only one place to go – Birmingham.

Travelling towards Birmingham by canal one soon learns to appreciate one fact, that the city is built on a plateau: from whichever direction you approach there is a long climb through many locks. A

ANNO UNDECIMO

Georgii III. Regis.
c. 67

An Act to oblige the Company of Proprietors of the *Birmingham* Canal Navigation to complete the said Canal to a Field called *New Hall Ring*, adjoining to the Town of *Birmingham*, in the County of *Warwick*, within a limited Time, and to maintain and keep the same free and open for the Passage of Boats, Barges, and other Vessels. [1771]

Above
The Act of Parliament authorising construction of the first Birmingham Canal.

Previous page
Old canal and new buildings, Birmingham.

Travelling up to the centre of Birmingham. The Birmingham and Fazeley Canal passes under a large office block, 'Brindley House'.

good place to begin a trip through Birmingham is at Farmer's Bridge Junction, just off Broad Street, near the city centre. It is a canal cross-roads where the Worcester and Birmingham and the Birmingham and Fazeley Canals meet and where the Birmingham Canal itself begins. This complex of canals is a feature of Birmingham for the area has become so criss-crossed by different waterways that they have been given a generic name – the Birmingham Canal Navigations or, more commonly, plain BCN. The junction itself is a triangle of water, flanked by what used to be an extensive wharf area, where goods were loaded and unloaded, and warehouses where the goods were stored. Today, the most prominent feature is a new pub. But reminders of the old commercial life do remain. You can, in fact, deduce a good deal about the nature of the British canal system just by observing the buildings and structures of this one spot.

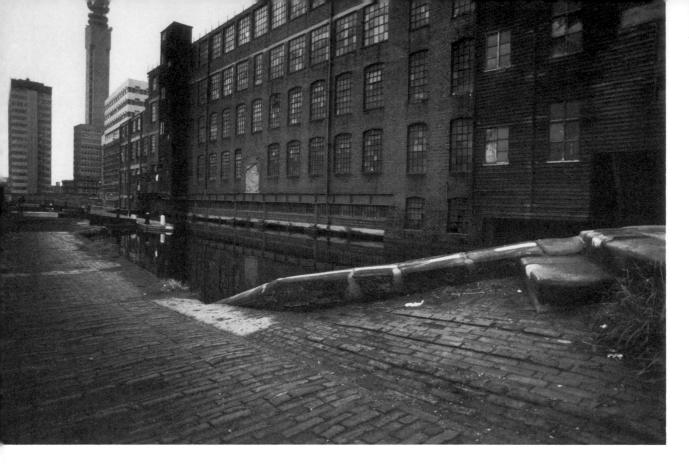

Canalside warehouses with wood-covered hoists, under which boats were loaded. The towpath is ridged to provide a better footing for horses.

The wharf area has already indicated cargo, and another building tells you how that cargo and the canal that carried it were financed. On the opposite side of the basin from the pub is a small, hexagonal building jutting out from the wall that marks the boundary of the canal property. It is a toll house, built to the same pattern as the toll houses on the new turnpike roads, and for the same purpose. Canals are expensive things to build, and the British canal system was built up piecemeal. The idea for a canal was put forward, usually, in the early days, by local businessmen and manufacturers, and a company was formed. The company then had to obtain an Act of Parliament empowering them to build the canal, and the shareholders had to find the cash to pay for it. Some supported the canal because they had businesses in the area and the waterway was essential for development; others were speculators, investing money in the expectation of drawing more money out. Businessman or gambler, both expected some sort of return on their investment. The return had to come from the profits the company made by charging all who used their canal. Hence the toll house and hence, too, its odd shape. Jutting out as it does, the toll collector had an all-round view of the traffic at Farmer's Bridge. No one could get by without paying his due.

The other notable feature is the long flight of thirteen locks that brings the Birmingham and Fazeley Canal up to the junction. The lock, properly known as the pound lock, was in use in Italy as early as the fifteenth century. It is a simple device: water can be let into or out of a chamber, enabling boats to rise or fall. The ends of the lock are closed

The toll house at Farmer's Bridge Juntion. All boats had to stop here to pay their dues.

by watertight gates which, in the earliest versions, were of the portcullis type, opening vertically. These were not very efficient and were soon replaced by the now familiar mitre gates, which meet at an angle as in a carpenter's mitre joint. The pressure of water behind the gates keeps them closed. The inventor of the mitre gate was that great Italian polymath, Leonardo da Vinci.

Locks have a unique importance for any canal system, and not just because they are the common means for getting boats up and down hills. Once you have fixed the size of the lock, then you have fixed the size of boat that can use the canal, for it simply has to be able to get into the lock. These locks are 75 feet long and just over 7 feet wide. We owe

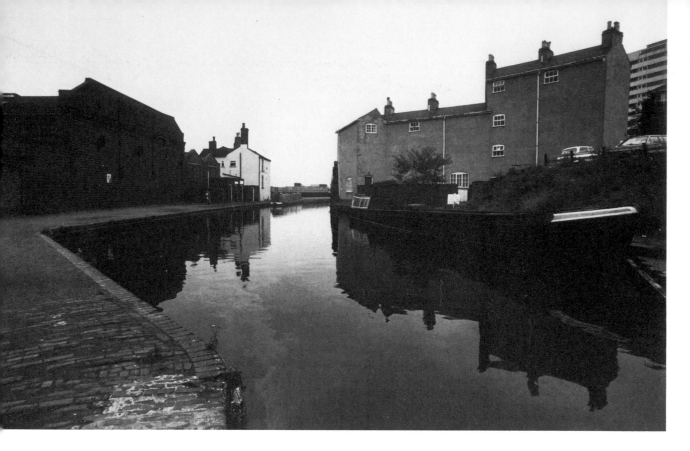

these dimensions to the man who totally dominated the early years of canal building, James Brindley.

The typical 70-foot narrow boat of the Midlands canal network.

Brindley had been employed as engineer by the Duke of Bridgewater, and when that canal proved an immediate success he received a good deal of the credit. It now seems likely that the Bridgewater Canal owed as much to the Duke's agent, John Gilbert, as it did to Brindley, but at the end of the day Gilbert stayed with the Duke while Brindley was the man available to other canal promoters. He was soon involved in the building of the flight of locks that took an extension of the Duke's canal down to the Mersey at Runcorn. The Mersey was already used by its own type of craft, known as flats. These were roughly 70 feet long and 15 feet wide, so the locks were built to fit them exactly. When Brindley moved on to new canals, there were no such restrictions: he could choose whatever size seemed appropriate. He could have kept to the Runcorn formula, but he decided against that. Possibly he was worried about the amount of water such large locks would use. Equally he might have been thinking of a quite different type of vessel for his canals, one based on the long, narrow boats used by the Duke of Bridgewater to carry coals out of his mine at Worsley. Whatever the reason, he decided to build locks to just half the width of those at Runcorn. This became the standard for much of the canal system, and from this choice the most familiar of canal boats followed. The canal narrow boat is 70 feet long with a 7-foot beam. It can carry a load of up to 35 tons, which might have seemed a lot in the 1760s, but was to prove quite inadequate when newer forms of transport began to offer competition.

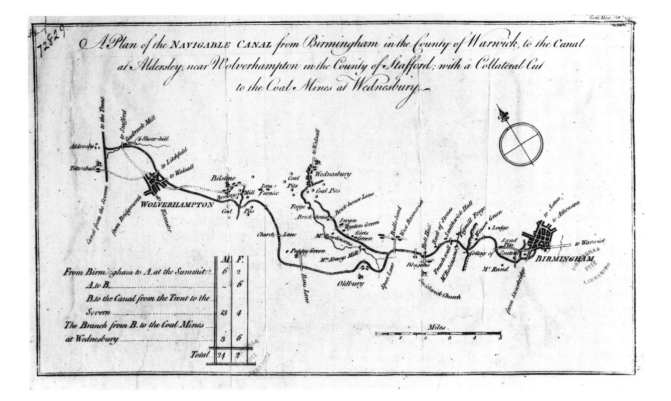

Map of the original Birmingham Canal, showing the wavering line that typifies the contour canal.

Here already we have the skeleton of a canal system, paid for by its users and financed by a profit-making company. It was a system based largely on the narrow boat – largely, but not entirely. One of the major disadvantages of the British system lay in the multiplicity of companies. In the early days, not all employed Brindley nor did they all adopt his lock size. On the Leeds and Liverpool, for example, the locks are twice as wide but shorter, so that everything had to be transhipped between wide boat and narrow boat. Companies tended to see each other as rivals rather than as partners in a unified network. Yet, in spite of the problems, the canal system was a success. Water was, and is, just about the cheapest way of carrying goods. Engineers conducted a series of experiments to see what load a single horse could shift by various means. The results were, to say the least, significant: at one end of the scale was the pack horse humping its load over rough tracks. It could carry one eighth of a ton. Load up a waggon and put that waggon down on one of the new turnpike roads and the horse could move two tons. That could be improved still further by putting the waggon on iron rails – eight tons was then the maximum load. But set your load on the waters of a canal and the figure rocketed up to 50 tons. These were the statistics that spelled out the reasons for the success of the canal system.

From Farmer's Bridge, the Birmingham Canal leads northwards to Wolverhampton. Building work began in 1768 under the direction of Brindley. Look at the original map and you can see why it was built: coal pits are marked at Wednesbury and Wolverhampton and there were customers for the coal in the forges and ironworks all

along the route. The same map shows a good deal about Brindley's planning. This Birmingham Canal might be an artificial waterway, but it twists and turns like a natural river. This is because Brindley favoured a method known as contour cutting. He preferred to keep his canal on the level and so avoid any extensive or complicated engineering works. He followed the natural contours of the land, bending and curving to avoid both hump and hollow. It made for long and difficult journeys, particularly when the canal became very busy, which certainly happened in the case of the Birmingham Canal. Trade grew and the Company prospered. Shares which cost £140 in 1768 were worth £400 by 1782 and ten years later they had leapt to £1170. A better canal would have meant even higher profits so, in 1827, Thomas Telford was called in to look at the canal to see if it could be improved. He proposed a radical measure: a brand new Birmingham Canal that would cover much the same ground, but would run straight and true. It would lop 7 miles off the 22-mile journey to Aldersley where the Birmingham Canal met the Staffs and Worcester.

Telford's technique was very different from Brindley's. He sliced through the contours, cutting deep into the high ground and using the spoil from the cuttings to build embankments across the valleys. The method is known as 'cut and fill'. It is a far more efficient system of canal building than contour cutting, which is not to say that Telford was a better engineer than Brindley. James Brindley was a pioneer, evolving techniques as he went, working with inexperienced men and crude tools. Telford was able to draw on Brindley's experience and that of other engineers over the past half century. He also had the advantage of being able to call on experienced, full-time canal diggers, known as navigators or, more simply, just navvies.

Contour cutting and cut and fill represent the two principal techniques used throughout the canal age, and in the two Birmingham Canals they can be seen laid out side by side for comparison. Looking at the line leading away from Farmer's Bridge, the existence of the old canal might seem to be in some doubt. There are, however, a number of turnings off the main line. The first is at the junction with the Worcester and Birmingham, but if you take the second turn you will find that it will loop round to arrive back on the main canal. It is, in fact, part of the old line. Its meanderings may have been aggravating for boatmen trying to hurry on through, but they performed one very useful function: they served a multiplicity of works along the banks. So, when the new line was completed, the old meanders were left as a series of these loops: Oozells Street Loop, Soho Loop, Icknield Port Loop. Take a boat down any of these – no easy job for they are little used and tend to be full of rubbish – and you can see just how exaggerated the curves of the Brindley line were, but also just how successful the canals were in attracting industry.

The main line of the Birmingham Canal, seen from the Engine Arm aqueduct.

Right
Cast-iron bridges are a distinctive feature of the Birmingham canals. Here the bridge crosses a junction, with the Worcester and Birmingham Canal leading off to the left, the Birmingham Canal to the right.

Left
The M5 motorway striding across the Birmingham Canal at Spon Lane.

In turning down one of those loops you will pass under a simple curving cast-iron bridge. During the first century of canal use, the horse was the motive power for the boats, and these little bridges were needed to carry the horse using the main line across the loops. Stop and look at these bridges and you will see that the pathway is ridged to help the horse get a grip. They are also a measure of the modernity of the Telford Canal. Cast iron had replaced stone and brick as the major building material, and these bridges were mass produced from the same casting. They are one of the trademarks of the BCN.

At Smethwick, the two routes diverge to run parallel. The old Brindley canal climbs up the hillside through a little flight of three locks, while the new route dives through the rising ground in a deep cutting. The character of the canalside scenery also diverges. The old route is more closely set round with industry, with factory wharves where goods were loaded and unloaded. The new, being primarily a through route, tends rather to keep itself to itself, isolated in its cuttings or looking down from a high bank. Following the new line, it is the scale of the civil engineering works of the canal itself that makes the strongest impression. Deep cuttings presented special problems to the builders, the main one being how to get the excavated dirt up to the surface. There was virtually no mechanisation, no powered excavators, and the spoil had to be raised to the top of the cutting by means of the barrow runs. Planks were laid along the sloping side of the cutting and barrowloads of spoil wheeled up. The sides, however, are obviously too steep for a man simply to push the barrow up, so it was attached to a rope which was then fastened to a horse walking along a set track at the top of the cutting.

An arm runs off the upper level to cross the deep cutting on the splendidly ornate cast-iron Engine Arm aqueduct. The early aqueducts had all been built of brick or stone, necessarily massive to counteract the water pressure. In 1795 Telford, who had a job as assistant to William Jessop on the Ellesmere Canal, was asked to finish off the short Shrewsbury Canal, following the death of the chief engineer, Josiah Clowes. The canal was built to serve the great iron works of Reynolds and Wilkinson and was to include an aqueduct across the River Terne at Longdon. Telford and William Reynolds designed an aqueduct in which the water was carried in an iron trough. The experiment was a success, and Telford went back to his old job where he persuaded Jessop that a similar structure could be built across the Dee near Llangollen. But this was to be somewhat grander than the 15-foot high London aqueduct – it was the structure we now know as Pont Cysyllte. The iron aqueduct was magnificently established. The Engine Arm Aqueduct has neither the height nor the length of Pont Cysyllte, but it makes up for these deficiencies with its elaborate decoration. Gothic was beginning to replace classical as the fashionable style of the day, and though there is nothing here quite as riotous as was achieved by some Victorian engineers, the rows of pointed arches along the trough do produce a very rich effect. It is nowhere near as impressive, however, as the single, arched iron span of Galton Bridge that carries Roebuck Lane across the cutting, one of the finest of all Telford's works. Though ironwork structures undoubtedly provide the main glories of the Birmingham Canal, there were innovations as well in the high brick bridges. Some of these were built on the skew, a technique which calls for a very complicated pattern of brick laying in curved courses.

Telford's Engine Arm aqueduct carries a branch of the old canal across the new, straight main line.

The old Brindley Canal continues to thread its way up at the higher level. There are no spectacular features here. No bridge had yet been built of cast iron when this line was new, so here we find modest structures of brick. At Spon Lane, the old line crosses the new on the Stewart aqueduct, but both old and new are now literally overshadowed by the M5 motorway, striding above them on its tall, concrete legs. The routes for old and new become widely separated as they head towards Dudley and the flat, windswept wastes of the Black Country. It is an area that shows some evidence of present industrial use, and rather more of the past in a wide spread of waste tips. It may not be beautiful country, but it was to serve just such heavily industrialised areas that the canal was built.

Dudley Port Junction marks the arrival from the south of the Dudley Canal or, to be more exact, the Dudley Number Two Canal. As the name implies, there was also an earlier Number One. This was built between 1776 and 1779 in conjunction with the Stourbridge Canal to join the busy centre of Dudley with the Staffordshire and Worcester Canal and through that to the Severn. There was now a canal linking Dudley with the south-west; there was also a short arm that stretched down towards the town from the Birmingham Canal. This was the privately-owned Lord Ward's Canal, built by John, 2nd Lord Vincent Dudley and Ward. In spite of its impressive name, the canal was only half a mile long and ended in a tunnel which speared into the hillside to connect with underground limestone workings. Between these canals was the high ridge which dominates Dudley.

In 1785 an Act of Parliament was passed approving the construction of a tunnel through the ridge and work on the Dudley tunnel began in a glow of optimism which turned out not to be entirely justified. The first stage in tunnel construction was to carry out a survey on the surface. Points were lined up across the ridge and shafts sunk along the line. Bearings taken above ground were then converted into headings dug out from the bottom of the shafts below ground. At Dudley, the shafts were later filled in, but there were about a dozen in all. Theoretically all headings should meet to form a continuous straight tunnel, but as any traveller through canal tunnels will know, theory and practice do not always coincide. Spoil from the diggings was wound up the shaft by a horse gin, such as were found in mines of the period and, again as in mining, beam engines had to be brought in to pump water from the works.

Paddle gear for winding up paddles at the lock.

Work began in September 1785, and the completion date was fixed at March 1788. The work went on in fits and starts: chief engineers came and went; cash ran out and more had to be raised, and it was not until 1792 that the tunnel was finally declared open to receive traffic. The three-year schedule had stretched to seven. Even then it was only able to take one-way traffic, and a parallel tunnel was constructed at Netherton in the 1850s on the Dudley Number Two Canal. Turning off the Birmingham Canal, Netherton tunnel soon appears, a wide, straight bore, capable of allowing two boats to pass and having a towpath on either side to allow for this two-way traffic. From here the canal swings round in a great arc to finish up at Park Head locks with their accompanying pumping station, built to supply water to the canal. And there at the bottom of the locks is the entrance to Dudley tunnel. It is not particularly impressive, and gives no hint of the extraordinary underground world that lies behind the portals. The first thing one notices about the tunnel is not only that it is not wide enough to take two boats, but it scarcely seems large enough for one. Also, it has no towpath, so horses had to be unharnessed and taken over the hill to wait for the boat at the other end. In the mean-

The Dudley Canal Company seal, showing the tunnel, castle and old Newcomen engine.

time the boat had to be worked through manually. It could be shafted, which is a process rather like punting, or it could be legged. Two leggers would lie on their backs on a plank laid across the boat and rest their feet against the tunnel walls. They would then begin a curious sideways walk, pushing the boat on through the tunnel. In wider tunnels, such as those on the Grand Union, special legging boards were used which projected out from the sides of the boat.

The coming of powered boats did not put an end to legging at Dudley. The ventilation is so poor in the tunnel that engine fumes become a real danger. So modern pleasure boaters must do as the working boatmen did. In fact, few pleasure boats can fit into the low, narrow tunnel and most visitors travel on a specially modified passenger boat.

At first the tunnel seems a reasonable size, if a little cramped, and the walls are smoothly lined with blue engineering bricks. This is the 'New Section', rebuilt in the nineteenth century after mining subsidence had affected the original. It ends abruptly some 200 yards from the entrance: the tunnel narrows, the roof is lowered a couple of feet and the engineering bricks are replaced by rough eighteenth-century brickwork. You are now in the old tunnel. At 850 yards you get a glimpse of the sort of material the tunnellers had to force their way through. The brickwork ends and you see the rock, known as 'Rowley Rag', a type of basalt. Here you can see the traces of bore holes in which the workmen placed their charges for blasting. It was rough and ready work. The height and width of the tunnel vary considerably, and there is a kink where two headings failed to meet. A little further along you can see slots in the roof where generations of boatmen have pushed with the end of a boathook to shaft their way along. The rules forbade this activity, but were unenforceable as no one could know what was going on in the dark hole underground.

The tunnel is not simply part of a transport system, it is also part of a mine and quarry complex. One and a half miles in from the entrance, the passage suddenly opens out into a spectacular underground junction. A branch leads off to the right which connects with limestone workings under Castle Hill. Originally this was a basin, open to the sky and there was a lock at this point. Then, because of the dangers of falling rock from the quarry, the whole basin was given its present high-vaulted roof and the brickwork was covered over with spoil as a protection. In effect, this is tunnelling by a different technique, cut and cover. The tunnel is made as a deep cutting and then roofed over. A short way beyond this section, known as Cathedral Arch, the whole tunnel does actually open out into a deep basin, its steep rock sides covered with trees. Castle Mill Basin once had four tunnels leading out of it. One of them went under Wren's Nest Hill, where there were two more basins. This was the focal point of a labyrinth of workings from which limestone was quarried right

up to the 1920s. The main tunnel continues on through an entrance that looks quite insignificant, set at the bottom of a tall rock face. There is one more basin, then a short run through the old Ward tunnel before you finally emerge at the Tipton end. The whole trip is almost two miles, and though Dudley is not the longest tunnel on the canal system, it is certainly the most remarkable.

Emerging from the tunnel, a sharp right turn brings you into the old arm of the canal that leads to the lime kilns, where the limestone from the quarries and mines was treated. Lime is a base used for treating acidic soils, and it is formed by heating the limestone which breaks down into soluble quick lime. The arm of the canal has to bend right back to reach the kilns, and the area enclosed in the crook of the arm is now the home of the Black Country Museum. Here are examples of the small and large industrial concerns which made up the canal's customers: nail makers at one end of the scale, the rolling mills of the iron workers at the other. Most of the buildings have been taken down and re-erected here because they were threatened with demolition. All have relevance to the canal story, because they were part of the community that the canals helped to develop.

Castle Mill basin, where the Dudley tunnel opens out into limestone workings. The tunnel entrances can be seen on either side of the man-made basin.

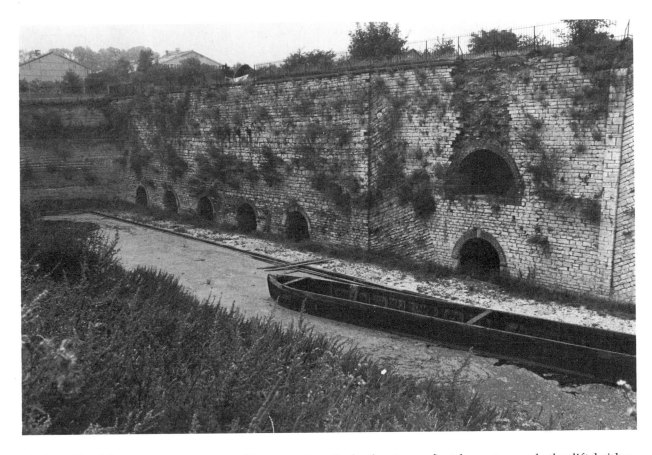

The huge lime kilns where limestone from the quarries served by the Dudley tunnel was burned.

To enter the site by boat you first have to work the lift bridge. Moveable bridges have always been a feature of the canal scene. Most are either lifted at an angle on a simple lever principle or pivoted to swing horizontally. This Tipton bridge is unusual for it does neither: the whole platform lifts vertically. The mechanism is worked by a windlass and the effort is reduced by the use of counter weights. At the canalside is a small, typical Black Country boat yard, just the sort of thing that could once be seen dotted along the length of the BCN. The maintenance shed was knocked up from the most readily available material, a disused narrow boat. The side of the shed is, in fact, the boat bottom. There are boats in plenty on the water within the museum site. The typical craft of the BCN was the day boat. These never made long journeys, so there was no need for the crews to live on board. These are boats at their simplest, little more than 70-foot long hulls. The BCN was also used by boats passing through on long hauls, for this was the hub of the whole system. In the early days, the boatmen were land based, but as routes extended and as competition made heavier demands on the boat people, so more and more families took to the water, living their whole lives on the boats. This

Above
Old working boats preserved at the Black Country Museum.

Left
The Black Country Museum. The bridge was saved from demolition and re-erected here. Originally it crossed the Birmingham Canal at Wolverhampton.

new nomadic community began to take on its own unique identity and by the end of the nineteenth century this was showing itself in the boats themselves. The boat families decorated them with geometrical patterns, with roses and daisies and with romantic scenes of castles and rivers. They also learned to organise their cabins – and to run a successful family life in a space little more than six feet square requires almost a miracle of organisation. Yet in spite of this cramped living space, the cabins could be as neat and as cheerful as any land home. The furnished back cabin of the narrow boat 'Diamond' on show at the museum looks very fine, but it is no finer than many a cabin on many another working boat.

The canal building period was a brief one, just over half a century, but the canals served the industrial revolution throughout the period of greatest change, and served it well. Indeed, without the canals the industrial revolution would scarcely have been possible. They also helped to ease the path for the next major transport innovation. Canal engineers pioneered techniques in civil engineering which formed the basis for the work of railway engineers. They also developed a skilled work force, the navvies, who were available for work as soon as railway construction began. If industry could only have advanced with difficulty without the canals, then the same is true of the railways. They drew on the canal builders' experience and went on to become the canals' greatest rivals.

The interior of the back cabin of the narrow boat 'Diamond'. This shows the whole of the space that was available to a boat family as a home.

Steam on the Move

The railways were with us for a very long time before anyone even thought of the steam locomotive. References go right back to the sixteenth century, when an early version was introduced to serve mines in Germany. There the trucks had pins underneath which fitted into a slotted board. But the use of actual rails seems to have begun with the collieries of Britain. Ideally, the mine owners would have liked to send all their coal out by water, but as mines had to be dug further and further away from navigable rivers so a new form of transport had to be developed. At the end of the sixteenth century, two colliery railways were laid down, one from Wollaton to the Trent and the other from Broseley to the Severn. The tracks had wooden rails and were built on a gradient, so that loaded trucks could run down under gravity while the empty trucks could be hauled back by horses. The main area for the development of these railways was the north-east where they served the collieries of Tyne and Wear. Iron rails were introduced early in the eighteenth century to replace the wooden ones. At first they were simply metal plates with a vertical flange on the inner edge to keep the waggons on the track. This system had the advantage that trucks could be taken off the tracks and used on the road. In the 1760s rails were being cast at the Darby works at Coalbrookdale, and edge rails for use with flanged wheels were introduced.

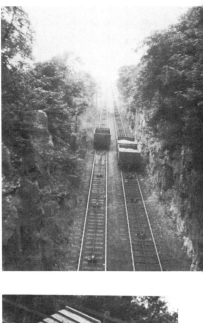

Ironically, in view of later history, it was the success of the canals that helped to spread the early railways. There were places that canals could not go – areas so hilly that the expense of lock building would have been prohibitive, even if enough water could have been found to supply them. One such area was South Wales, where the landscape is made up of high ridges, running north and south, with valleys in between. The canals could easily follow the north–south lines of the valleys, but cross connections had to be made by rail. So railways developed which were not so much transport routes in their own right as the servants of canals. A similar situation could be found in the north of England.

At Cromford, in Derbyshire, a canal was cut in the 1780s to serve Richard Arkwright's cotton mills. Across the Pennines, another canal was built, the Peak Forest, largely to serve another cotton magnate, Samuel Oldknow. It ended among the hills at Whaley Bridge. Cromford is 277 feet above sea level, Whaley Bridge 517 feet, and in between were moors rising to 1264 feet, but on those moors were valuable deposits of limestone. There was obviously a case for linking the two canals and a third canal was even proposed, albeit briefly. Instead an Act was passed in 1825 authorising the construction of the Cromford and High Peak Railway.

The country was, to say the least, unsuited to railway construction. The route eventually taken was described by a nineteenth-century tourist as consisting of 'corkscrew curves that seem to have

Above
The Middleton incline on the Cromford and High Peak Railway in its working days.

Below
A planeman controlling traffic on the incline.

Previous page
'Locomotion' under steam.

136

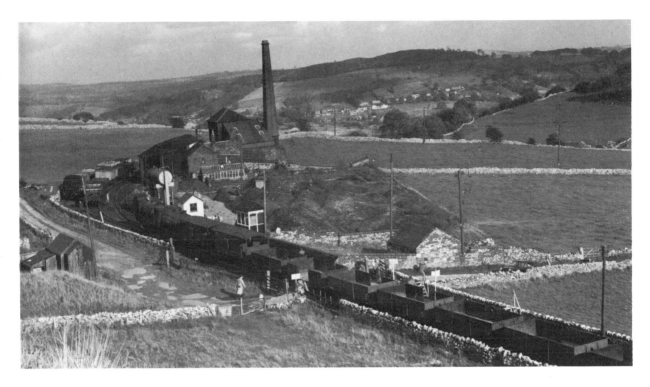

The top of the Middleton incline, when the railway was flourishing.

been laid down by a mad Archimedes endeavouring to square the circle'. But, for all the twisting and turning, there were still those hills to be overcome. No horse could be expected to cope with such gradients, and the answer was found in the steam engine.

The steam engine had already been adapted to turning a wheel as opposed to lifting a pump rod, and there was little fundamental difference between using the beam engine to haul a cage up a colliery shaft and using it to pull trucks up a steep hillside. So, engine houses were built at the tops of the various inclines. At one time there were no fewer than seven such engines on the Cromford and High Peak. Today one survives.

The energetic who want to see something of the line can start down at the Cromford goods yard in the woods beside the Cromford Canal, close to the A6. Here are the old maintenance workshops with their rails still in place. From here the line can be followed up the first of the inclines, Sheep Pasture incline. At the foot is a catch pit, installed after runaway trucks had careered down the rails and shot straight across the main road. It is an alarming thought, even more alarming when one considers that passengers were once carried on this railway. Then there is a short level section – and level sections on this line are achieved much as they were on Brindley's canals, by hugging the contour of the land. Then follows the 1 in 8 Middleton incline with its engine house at the top.

Middleton Top engine house is a striking building in a dramatic moorland setting. It is hexagonal, with a lean-to boiler house at the back and a tall stack. There is a touch of elegance in the windows, which have arches and interlocking tracery – the Gothic Revival was in vogue at the time. Inside, the machinery has been preserved in working order. Power is supplied by a pair of identical beam engines, each having a 23-inch diameter cylinder and a 61-inch stroke. The beams are sixteen feet long. At the opposite ends of the beams from the piston rods are connecting rods, attached to a common crank. The two engines used to work at a rate of 40 rpm.

The winding mechanism looks rather complex at first sight. Two wheels, each fourteen feet in diameter, stand one above the other in a deep wheel pit. A third slightly larger wheel is in between, overlapping the other two. Cable was wound round these wheels in an intricate pattern. The actual winding wheel is the lowest of the three, which is driven by means of gears which engage with a small gear wheel on the crankshaft. The top wheel is simply an idler, carrying the haulage cable, and the third is a flywheel. At present, the wheels are connected up simply for display purposes, but in their working days they carried a continuous cable. It came up from the waggons on the incline, and entered the wall below the window. It then passed to the winding drum, which it wrapped around with a three-quarter turn, passed up over the idler wheel, back down to the drum, up again to the idler and out through the wall. Outside you can see where the cable went round two pulleys, one for each of the two tracks of the incline. From here the cable went all the way down to the bottom of the incline and back up again. The circuit was complete. The cables themselves were kept in place by rollers set between the tracks. Chain and rope have been used at various times as well as cable.

Middleton Top looks like a relic from the first period of the industrial revolution and yet it continued in use right up to 1967. By then locomotives were running on the line and they too had to be hauled up and down the various inclines. It was always a relic, though, in one sense, for even during the period it was being built it was already out of date. It looks back to the idea of railways as no more than useful canal connections, and it is a very cumbersome device for moving trucks on rails. All that heavy machinery had to be cast at Butterley Iron Works at Codnor Park and then hauled up the hill for assembly. Fuel had to be carried up to feed the boilers and a reservoir had to be built to ensure a water supply. And all this just to turn the one wheel, the winding drum. Men were already looking at an alternative. Use the steam engine to turn the wheels, but put the wheels on the track and let the engine go along with them. Transform the stationary engine into a mobile one, the locomotive.

The Boulton and Watt low-pressure beam engine was a magnificent creation, but the all-embracing patent given to Watt effectively

Above
The 'hanger on', fastening a truck to the cable ready to be hauled up the incline.

Right
Middleton Top engine house as it is today. The railway has gone, but the engine house with its winding engine has been preserved.

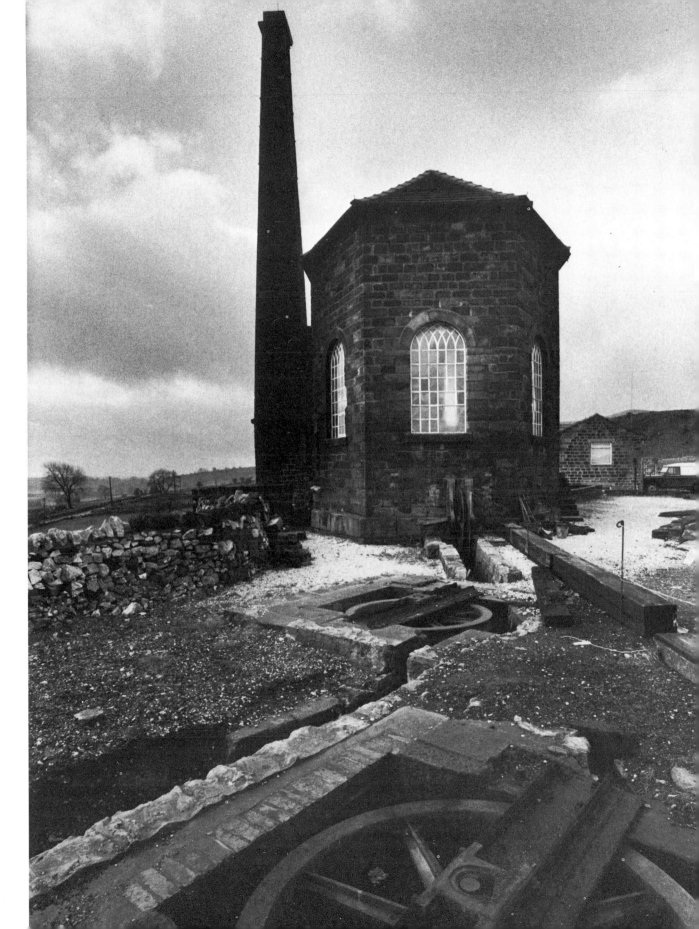

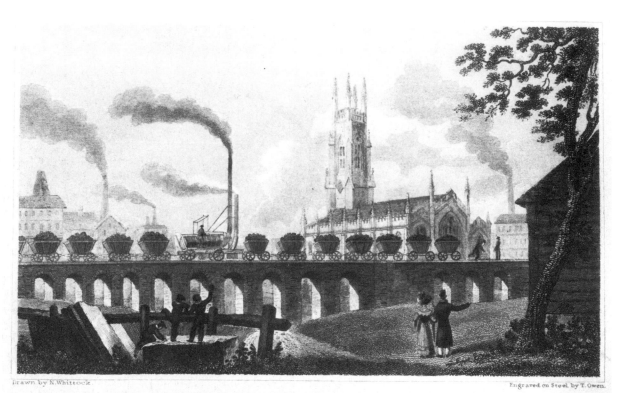

Drawn by N.Whittock.

Engraved on Steel by T. Owen.

CHRIST CHURCH AND COAL STAITH, LEEDS.

stopped all further development until the beginning of the nineteenth century. James Watt clung tenaciously to the use of steam at low pressure, which meant huge engines which could certainly not be moved around on rails. When the patent expired in 1800, work on high-pressure engines began in earnest. By using the expansive power of steam to push a piston, you can increase the force by increasing the pressure. So you can decrease the size of the engine, and still get the same amount of work from it. There were some early experiments with steam road vehicles by Cugnot in France in 1769 and Murdock in Cornwall in 1785, but the credit for developing the first successful steam locomotive belongs to Richard Trevithick. He was a Cornishman, brought up among the steam engines of the tin and copper mines. He was a brilliant inventor, but a terrible business man. He too began with a road vehicle. His first ran quite successfully and Trevithick and friends went off to celebrate the occasion at a local hostelry. The engine, left to its own devices, dried out and the boiler blew up. Trevithick had rather more solid success with a locomotive that he built at the Darby works in Coalbrookdale in 1803. The following year he successfully ran a steam locomotive pulling ten tons along the plateway of the Penydarren tramway in South Wales. He proved one thing beyond doubt: the smooth-wheeled locomotive would work on smooth rails. It was a major advance, and his locomotive had a number of important features, including an idea which was to be resurrected many years later by which the exhaust steam was turned back up the chimney to increase the draught to the fire.

Above
The world's first commercially successful steam railway, the Middleton Colliery Railway at Leeds.

Right
The Delph locks, leading away from Birmingham towards the south west.

140

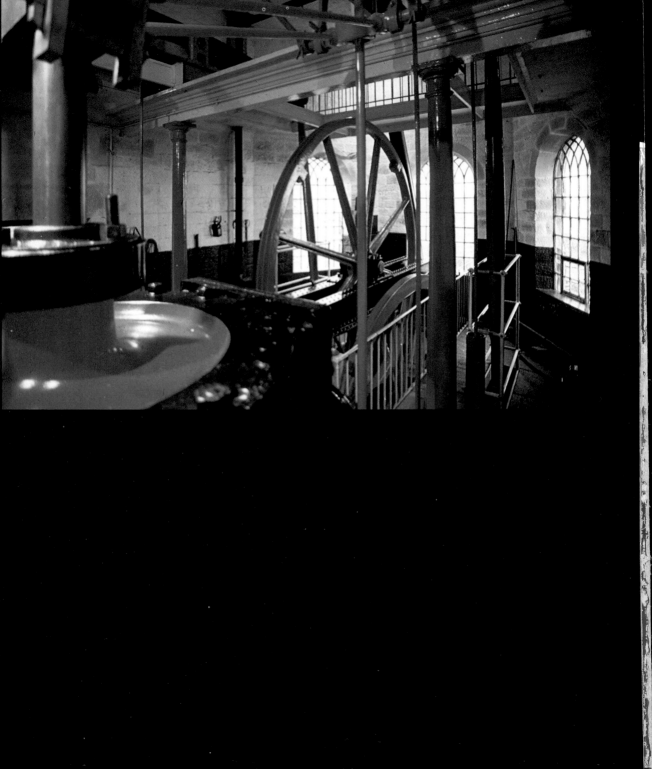

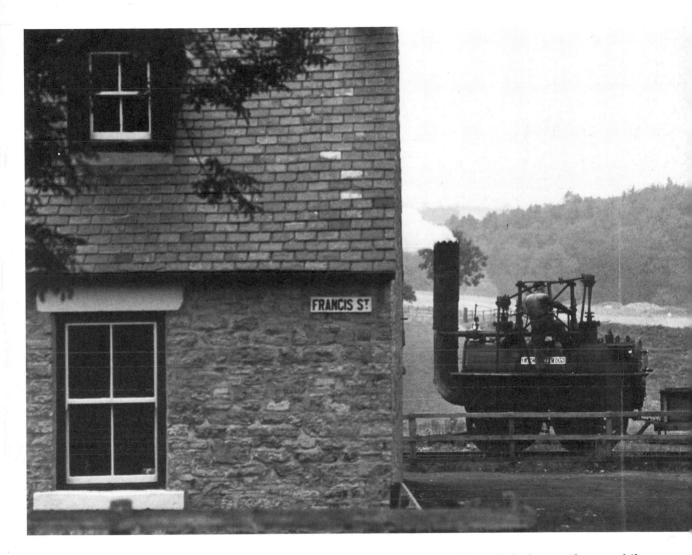

Above
A working replica of the Stockton and Darlington Railway's 'Locomotion' at the North of England Open Air Museum, Beamish.

Left
The winding engine in Middleton Top engine house.

The early locomotives were, in effect, little better than mobile beam engines, but they worked. Why then was the development so slow? Why was there no rush to build on Trevithick's success? There were two main reasons, one economic, the other technical. The economic one was simple enough: horses were cheaper than steam locomotives. The technical problem had appeared at Penydarren. The locomotive had run well enough, but only at the expense of a badly damaged track. The cast-iron rails simply could not take the load. As long as the economic argument held, there was no incentive to overcome the practical problem. Then came the Napoleonic Wars, the cost of fodder shot up and in Leeds two men, Blenkinsop and Murray, combined their talents to overcome the rail difficulty. The result was the world's first successful steam railway.

John Blenkinsop was manager of the Middleton Colliery just outside Leeds. It was already joined to the Aire and Calder Navigation by a waggonway which, incidentally, was the first railway of any kind to be authorised by an Act of Parliament. That was in 1758. Blenkinsop was worried about mounting transport costs and applied his mind to the problem of cracked rails. Trevithick had shown that adhesion between smooth wheel and smooth rail was possible, but if useful work was to be done the locomotive needed to be heavy. Blenkinsop hit on the idea of building a third rail beside the tracks. This was toothed and engaged with a toothed cog on the engine. This is what we now know as a rack and pinion system, still in use on mountain railways such as the one up Snowdon. With the extra adhesion, a comparatively light locomotive could haul a heavy train.

The design and construction of the locomotive was entrusted to a local engineer, Matthew Murray, who had established a considerable reputation as a designer of textile machinery. He built two locomotives, *Salamanca* and *Prince Regent*. In June 1812 the system was opened and eight waggons loaded with coal and as many spectators as could manage to cling on ran a triumphant course from colliery to river. The Middleton railway is rarely awarded a very important place in the railway annals simply because the rack and pinion system was soon made obsolete by the introduction of the rolled iron rail which could carry heavy traffic. Yet it was the first and it was successful and many came to see it at work, including the Grand Duke, later Czar, Nicholas of Russia and a colliery engineer from the north-east, George Stephenson. He came in 1813, a year before he built his own first locomotive.

Early Stephenson locomotives were still recognisably in the beam-engine-on-the-move category. In 1822, George built an engine for the Hetton colliery and this locomotive, though no longer in steam, is preserved at Beamish Museum. The engine has two vertical cylinders let into the boiler, which drove two coupled wheels. It looks distinctly crude with its crossheads stuck up above the boiler, but it worked well enough to continue in use until 1912. Another early locomotive type can be seen at Beamish. This is not a genuine old locomotive, but a replica built as nearly as possible to the original specifications. It is Stockton and Darlington Railway Number One, later dignified with the name *Locomotion*. Unlike the Hetton engine, it is regularly steamed.

Purists could, no doubt, make out a good case against the whole notion of replicas, but their great justification is that they let us see something of the working problems of early locomotives in a way that a static exhibit never can. Take the problem of reversing, for example. *Locomotion* has no reversing gear, so as the engine comes to a halt, the driver has to peer down from his platform at the side of the boiler to assess the position of the crank. This tells him which way the piston

A statue of George Stephenson in the National Railway Museum, York.

needs to travel to get the engine moving in the right direction. He then uncouples the valves and operates them by hand. When, hopefully, everything is moving in the correct way, he puts it all together again – with everything still moving. It is an extraordinary operation, but then *Locomotion* is an extraordinary looking engine which moves rather like an animated knitting machine.

The importance of *Locomotion* lies less in any mechanical improvements than in its role as principal engine on the world's first public railway, the Stockton and Darlington, which opened in 1825. Yet for all its importance, the s & DR was never more than a glorified colliery line, the passengers in the early days being carried in a special horse-drawn coach, mounted on the rails. The great advance came with the building of a major railway intended for mixed goods and passenger traffic, the Liverpool and Manchester. The directors were at first undecided whether to use steam locomotives or whether to rely on cable haulage by fixed engines, on the Cromford and High Peak pattern. Would locomotives be able to pull big enough loads at sufficiently high speed? The issue was settled by a trial at Rainhill, near Liverpool, in October, 1829. One of the competing locomotives successfully met and surpassed every condition laid down for the trial – Stephenson's *Rocket*. It set the pattern of locomotive building for a century, and it represented the culmination of the years of colliery experiments. What more appropriate place could there be at which to see the steam locomotive than at a colliery, and what could be better than Middleton Colliery? The railway here can notch up one more 'first' to its credit, for it was the first standard gauge line to be taken over as a preserved steam railway.

Unfortunately, few traces of the old railway laid down in the 1750s now remain. Much was lost under later railway developments and still more has vanished in recent years under a somewhat misguided tidying up of the area by officialdom. The assiduous hunter can still find many of the old stone sleeper blocks at various spots along the route, and a number can be seen incorporated into the platform from which passengers board for the busy week-end trains. But though the line is gone steam trains are still very much in evidence, running on one of the later lines. Here one can see locomotives which are the direct descendants of the colliery engines of Murray and the Stephensons. Though they are more sophisticated in detail, the main features are recognisably those of *Rocket*. Take for example the little tank engine built by Peckett in 1941. Until 1972 it chuffed away in the somewhat incongruous setting of the Nuclear Fuels plant at Cheshire. Yet in spite of its modern setting, it is still recognisably built to the *Rocket* pattern, if rather more sophisticated in its details. It has a very basic wheel arrangement, 0–4–0; that is, there are two pairs of coupled driving wheels, with no supporting wheels at either end of the locomotive. It is a small engine, yet considerably

larger and more powerful than the engines that competed at Rainhill. There the trial judges set a weight limit of 4½ tons and a steam pressure of 50 pounds per square inch: the Peckett is far larger and steam pressure has more than trebled. Although such changes add up to greater power and efficiency, they are not the result of any fundamental design improvements. Better rails meant greater possible loads; better boiler construction allowed higher pressures. The similarities are, in fact, more striking than the differences.

Left
The Middleton Colliery Railway today, running a steam trip for enthusiastic children.

Above
Preserved tank engines at the Middleton Railway. 'Windle' in the foreground has the characteristic shape of an outside-cylinder locomotive.

Right
'Windle's' name plates.

Rocket was, unlike the earliest locomotives, sprung, which meant a great saving in wear and tear on the rails as well as a more comfortable ride. The springing was laid down as one of the conditions of the Rainhill trial. Just as important for improving the ride was the positioning of the cylinders. In early locomotives, these had been set vertically, so that the engines tended to bounce along the rails. In *Rocket* they were set at an angle of about 35°, which still produced some bouncing, but in later Stephenson locomotives the angle was reduced to around 8°. This is about the same as we find in the modern locomotive. One reason why early locomotives look so very different from their later counterparts is the absence of any driving cab. The cab was a very welcome addition for the drivers, but does little to improve the efficiency of the engine, unless one discounts the fact that a warm, dry driver and fireman are likely to perform better and get more out of the machine than they would if they were soaked to the skin and half frozen. But if you can imagine the modern engine without its cab, it starts to look very much more like its forerunners. The firebox, into which the coal is shovelled, protrudes out onto the footplate. The main control, the regulator, is still a simple mechanical lever that allows more or less steam to the cylinders. The steam collection pipe is set high above the level of the water in the boiler. When the regulator is opened, the water tends to foam, and there is a danger of some of it passing into the steam pipe and down to the cylinders. So the actual entrance to the steam pipe is set up even higher over the boiler and covered by the tall steam dome. The regulator works on a valve inside this dome. The level of water in the boiler is shown in water gauges and the other more prominent feature is the reversing handle. Stephenson would have felt quite at home in this cab. Continuing on an outside inspection, as it were, there are the familiar bumps on top of the boiler – chimney, dome and safety valves. The latter have improved considerably since the early days of the Middleton Railway, when in 1818, an engine blew up, killing the driver. He was, according to the evidence of George Stephenson, drunk at the time and had overloaded the safety valve. The locomotive, however, is unlike *Rocket* in being a tank engine. Water is carried in a tank slung like a saddle over the boiler, instead of in a tender at the rear.

The main innovations introduced by Stephenson cannot be seen just by walking round the engine. You have to look inside the boiler. The early engines had contained the water to be boiled in a single or, at best, a double flue. In *Rocket* the boiler was made up of a series of 25 copper tubes, and later the number was greatly increased to enlarge the heating area. The actual force of the fire was increased by going back to Trevithick's idea of sending the exhaust up the chimney. Even if you cannot see the steam blast pipe, you can hear its effect in the familiar chuff-chuff of the exhaust steam. For well over a century, the

steam locomotive was the great workhorse of industry. It also helped to bring about a social revolution, a subject we shall be looking at in the next chapter. But although passenger traffic may have the greater glamour, it is in this working world that the locomotive was born.

The locomotive was not, in fact, the first form of transport to benefit from the power of steam: the steam engine took to the water before it arrived on the rails. The steam boat is one of the few inventions of the industrial revolution for which the British cannot take the credit. Nor, unlike the majority of the new devices of the period, was the steam boat the idea of some ordinary working man. The first successful voyage was made on the River Saône in 1783 by the paddle steamer *Pyroscaphe*, the brain child of the Marquis Jouffroy d'Abbans. After that, other nations took up the development. In Britain, William Symington produced a very sensible and efficient system. An engine with a horizontal cylinder was used to drive the paddle wheel through a connecting rod and crankshaft – the type of action we have just seen on the locomotive. His engine was fitted to a tug, the *Charlotte Dundas*, which went through successful trials on the Forth and Clyde Canal. Unfortunately, the canal authorities decided that the wash would damage the banks and the experiment ended. Development passed across the Atlantic to America.

In the early nineteenth century, the American paddle steamer came into its own. It was based on our old friend, the beam engine: in fact, it was little more than the old-fashioned beam pump in reverse. In pre-steam days, the water wheel turned in the current and, through the rocking beam connection, moved a piston up and down in a cylinder. Now the piston moved up and down to turn the wheel. It was a cumbersome device, but, like most beam engines, steady and reliable. It was not, however, very efficient. Other methods of propulsion were tried, including, at a very early date, jet propulsion. The Americans in the 1780s tried out a system in which water was pumped in at the front of the boat and shot out at the stern. It came to nothing. The major advance came when engineers went back to one of the oldest known devices for lifting water, the Archimedean screw. The idea of using a screw propeller came simultaneously from an Englishman, Francis Pettit Smith and a Swede, John Ericsson, designer of one of the unsuccessful competitors at Rainhill, and in 1838, the appropriately named *Archimedes* had successful trials. Five years later, one of the most famous of all screw-propelled ships crossed the Atlantic, Isambard Kingdom Brunel's *Great Britain*.

The *Great Britain* is rightly regarded as one of the world's great ships, and her return to her old dock at Bristol and gradual restoration are a source of delight to all enthusiasts. Sadly, she will never move again, but there is another vessel of the same date, also designed by Brunel, which can and does take to the water.

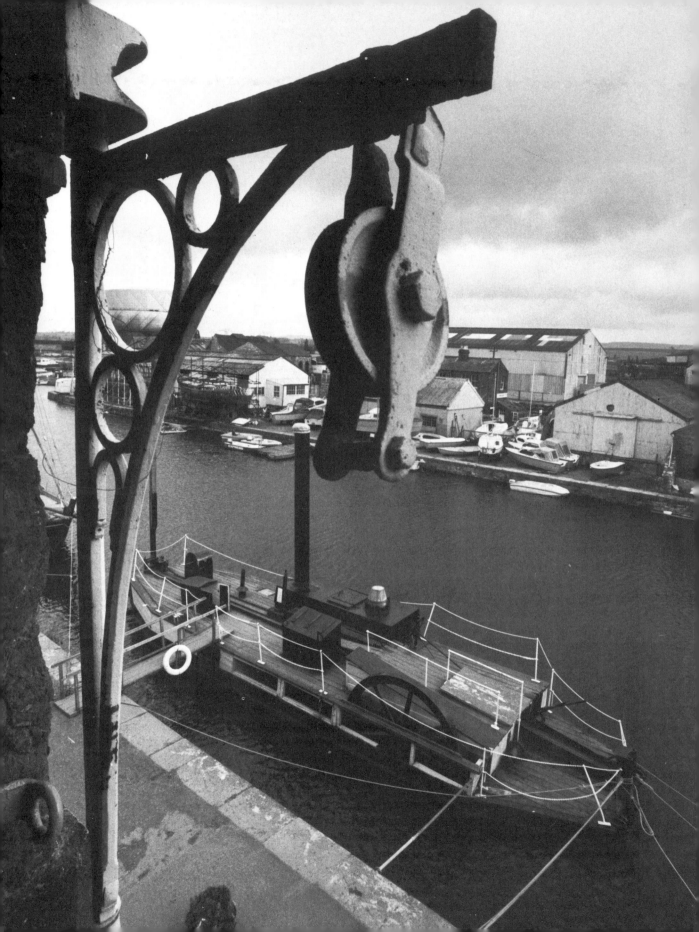

Bertha is a modest little lady when set beside the *Great Britain*, but nevertheless has a considerable claim to fame, for she is now the world's oldest working steam ship. She also has a direct link with her mightier sister. The *Great Britain* was not merely an engineering original, she was also extremely large for her day, and Bristol docks were only just big enough to cope with such a vessel. Fortunately, Brunel had already undertaken some dock improvements, which included building a special dredger to help keep the channel clear. It was a great success and another vessel of the same design was built in 1844 and finished up working at the Bridgwater docks in Somerset. This, it seems, was *Bertha*. There is room for doubt, simply because there is no documentation available, but she is certainly built to the same design as the original Bristol vessel. She is now one of the prize exhibits of the Exeter Maritime Museum.

The museum is based at the terminal basin of the Exeter Canal which itself has a long and interesting history. The canal was built in 1566 to bypass a weir on the river and it boasted the first pound lock to be built in Britain. The area around the basin has some splendid buildings, including the very handsome Customs House, built in 1681, and stone warehouses line both the canal and river sides. On the water, boats of many countries can be seen, *Bertha* among them, looking not unlike her designer: short and workmanlike, with a tall black funnel, very reminiscent of Brunel's famous tall black hat.

Bertha is normally described as a dredger, but might more accurately be called a scraper. That is not the only peculiarity that sets this

The piston and valves of 'Bertha's' engine.

vessel apart. In her working mechanism, she has rather more in common with something like the Middleton Top engine house than with a conventional craft. Here, too, a steam engine is used to wind a drum which works a chain haulage system. However, instead of hauling trucks on rails it is the engine itself – with *Bertha* attached – that is hauled along. The chains are fixed on opposite sides of the harbour that is to be cleared and the vessel winds itself from side to side. A boom in the stern carries the scraper, which is lowered to the bottom of the dock where it is held in position by drag chains. As the boat moves, the mud and silt are pulled into the centre of the dock where the action of current and tide can clear them away.

As befits a working boat, there is nothing fancy about *Bertha*. She is quite small, only 57 feet long with a 15-foot, 6-inch beam, and there is not a great deal to see above decks. The most prominent features are the tall funnel, the top of the flywheel coming up from the engine room and the boom. Below decks is equally spartan. Here you can see the single-cylinder steam engine, with its boiler and coal bunker and the winding drums for the chains. It is all very plain, but none the less fascinating for that. Like so many early machines, it is this very simplicity and robustness that has ensured survival.

Brunel's great steamships were first conceived as an extension of another transport system. It was at a meeting of the directors of the Great Western Railway in 1835 that he put up his revolutionary idea of a railway journey from London to Bristol that could be continued on by steamship across the Atlantic to New York. The first of the ships, the *Great Western*, attracted enormous interest and was a great success. However, for the general public it was the coming of the passenger railway that was to have the profoundest effect on their everyday lives.

Railway Mania

Today, I can board a train in London and be in York in two hours five minutes, travelling at an average speed of 92 mph. The locomotive heading the train is of a class that has run up to speeds of 143 mph. This locomotive is not, of course, powered by steam but by a diesel engine, the end of a line of development that began with Trevithick nearly two centuries ago. It shows the main characteristics of its predecessors – a self-contained unit, carrying its own engine and fuel, which can be attached to a variety of different trains. It is the last of that line, for its successors will be very different. Nowadays, we take the speed of travel for granted. Trains are still impressive when compared with road vehicles, but less so when set against supersonic travel in the air. Yet, looked at in terms of the past 200 years the development of land transport with increased speeds, greater comfort *and* reduced cost is a fair measure of one sort of progress. Compare that London to York journey at different periods.

In 1750, when road transport was at its worst, the journey time would have been at best four days, and could well have been more in bad weather. And that would only have been for the very small minority of the population who could afford any form of transport at all. At the beginning of the railway age, in the 1830s, new, properly surfaced roads and a regular stage coach service had reduced the time to 20 hours. Half a century later, in 1888, the railway companies were vying with each other to establish faster and faster services. Two rival companies offered trains to Scotland: the London and North Western Railway using a route up the west coast and the Great Northern Railway up the east. In those days, almost a century ago, the GNR timetable showed an express leaving King's Cross at 10 am and arriving at York at 1.30 pm – just three and a half hours for the whole journey, and that included a five-minute stop at Grantham. Competition went on until the 'Race to the North' culminated in victory for the LNWR in 1895, when they covered the whole journey from London to Aberdeen in 8 hours 32 minutes at an average speed of 63.3 mph.

Cost was just as important as speed. In 1844, Parliament passed an Act that decreed that all railway companies should run at least one train per day on all lines, and that the train should include a covered third class carriage with seats, for which passengers should pay a maximum fare of one penny per mile. Now people who had scarcely set foot outside their immediate neighbourhood could travel and see what was happening in the rest of the country. They could even take special excursions just for the fun of it, an idea that was born when the first excursion was run in 1841 by a young man who went on to turn the idea into a thriving business – Thomas Cook.

The Inter-City 125 service may be new, but its working relies on the rail system that was laid down in the nineteenth century. It began as a jumble of companies, large and small, often undercapitalised, frequently competing for business over duplicated routes. They were

Previous page
Crossing the viaduct over the Nidd at Knaresborough.

Locomotives grouped around the turntable at the National Railway Museum. The building was originally a locomotive maintenance shed, hence the cowlings for taking away the smoke above the chimneys.

pulled together in a series of amalgamations begun by the 'Railway King', George Hudson. In 1844 he joined together three large companies – the North Midland, the Midland Counties and the Derby and Birmingham Junction – to form one giant, the Midland Railway. His methods were not always scrupulous, his dealings considerably less than honest, and his years of glory were followed by years of disgrace. But the process of amalgamation continued, leading to big companies with money to spend on development. Hudson's faults were legion, but his ideas were sound and his capital city of York seems a good place to begin any railway story. It was here that he started his first railway, the York and North Midland, and in the days of success, the city made him its Lord Mayor. As the train draws into York under the great curving glass roof of the Victorian train shed, Hudson and the railway past are still very much with us. A short distance from the station is the National Railway Museum, where our heritage can be seen spread out in the form of locomotives, rolling stock and the bits and pieces that go to make up railway history. The museum buildings were adapted from the old York North Motor Power Depot where steam locomotives were serviced and repaired. It has two turntables, one of which has 24 sets of track radiating from it,

while the other has twenty. Locomotives are grouped around the first, coaches and waggons on the second.

The locomotives cover the whole range of steam development and go beyond to electrics and diesels. We have already looked briefly at some of the main features of locomotive development, but there is nowhere else where quite such an array covering the last century and a half can be seen under one roof. At one end of the scale is the colliery engine of 1829, *Agenoria*, very much the beam engine on wheels, and at the opposite end is the very last steam locomotive to be built for British Railways. It is properly known as a class 9F, a standard British Rail 2–10–0 design for heavy duty. The little tank engine of the Middleton Colliery railway seemed large compared with *Rocket* and its contemporaries: this is larger still, weighing in at 142 tons, while steam pressure has now reached the very high level of 250 psi. Others in this class were given the standard black paint job of the goods locomotive. But No. 92220, the last of the line, was decked out in passenger livery, embellished with a copper cap on the chimney and, because railway enthusiasts are romantics at heart, given the name *Evening Star*. In between these two extremes is a bewildering variety of locomotives. The story of development is especially complex because of the way the system evolved. Individual companies each had their way of doing things: the most famous example of a company going its own way is Brunel's Great Western Railway with its broad gauge of seven feet, compared with the 4 feet 8½ inches in general use in the rest of the country. This individuality extended to locomotive design. It has been said that at any time there were as many different designs as there were companies: an exaggeration, but not a big one. So, for the present we shall be concentrating on just one or two of the locomotives at York.

Every enthusiast tends to have his own favourites, so perhaps an author can be forgiven for dwelling on his. Of all the locomotives on show none is more handsome to this pair of eyes than the Great Northern's 4–2–2, No. 1 of 1870, the Stirling Single. It was designed for the GNR by Patrick Stirling and was generally acknowledged as the fastest of its day. The most striking features of the Stirling Singles, and the ones from which they got their name, are the single eight-foot diameter driving wheels. Such large wheels were only made possible by the invention of the steam sander, which gave them the necessary grip for starting. These Singles were the locomotives which carried the GNR banner in the Races to the North: one ran the 105 miles from King's Cross to Grantham in 101 minutes, while a second made an even faster run from Grantham to York at an average speed of 65½ mph. These were splendid performances, but the great virtue of these engines was consistency. They were not set up specially for fast, record-breaking runs, but continued to produce fast times, week in, week out hauling the Great Northern's regular express service.

Above
'Locomotion' and coal chauldrons at Beamish.

Below
The Middleton Colliery Railway, Britian's first preserved standard gauge steam railway.

Above
The huge driving wheel and sinuous lines of the Stirling Single.

Left
'Old Coppernob', the Furness Railway locomotive in the National Railway Museum.

The appeal of the Stirling Singles lies in the sheer beauty of the design. The huge circle of the driving wheel is emphasised by sweeping curves throughout the engine. The boiler is also notable for its smooth lines, for it lacks one of the 'bumps' which characterise steam locomotives – it has no steam dome. Stirling did away with it by using a steam collector pipe that ran the length of the boiler and which was perforated by a series of $\frac{5}{8}$-inch diameter holes. These stopped water passing to the cylinders just as effectively as the conventional raised pipe under the dome. Add to the basic design a dashing livery of green, lined out with black, red and yellow and you have something special indeed. Yet the Singles were a dead end in terms of railway development: the future lay with multiple drive wheels, the type of arrangement seen in one of their racing rivals.

Hardwicke is a 2–4–0 locomotive which ran in the final race to Aberdeen in 1895 for the LNWR. This particular locomotive took the 141-mile Crewe to Carlisle stage at an average speed of 67.2 mph. Multiple driving wheels did not mean simply, or even necessarily, more speed, but they did mean that a locomotive could pull greater loads. *Evening Star* has ten driving wheels, but perhaps the most famous and best loved of all the more modern classes is the 4–6–2 streamlined A4 Pacific designed for the London and North Eastern

Railway in 1935 by Sir Nigel Gresley. And of this class, the best known of all is *Mallard*, which on 3 July 1938 broke the world speed record for steam locomotives by reaching a speed of 126 mph on Stoke Bank. This was a deliberate try for the record, and it is interesting to compare this with the similar but regular working speed of the 125s. Progress on the railways has by no means ended.

As far as the passengers were concerned, developments in rolling stock were at least as important as developments in locomotives. The first coaches on the Stockton and Darlington Railway were simply stage coaches on rails, and first-class carriages followed this basic pattern for quite some time. The replica of the Bodmin and Wadebridge Railway coach on display shows its origins very clearly, while the unfortunate third-class passengers had to make do with a coach that was no more than an open truck with seats. By the 1840s, the s and DR had introduced composite coaches, with both first- and second-class compartments. The central first-class compartment, with its well upholstered seats, was flanked by the more spartan second-class accommodation. The poor old third-class passengers

'Mallard', the locomotive which still holds the world speed record for steam locomotives.

Vintage rolling stock from the Bodmin and Wadebridge Railway. Third-class passengers travelled in the open coach.

still had to make do with the open truck. There were still traces of the stage coach thinking in the design. Luggage was piled up on the coach roof where the guard had a seat. There was a series of coded whistles agreed with the driver, and when the signal came to stop, the guard had to clamber down to a precarious stance on the buffers in order to apply the brake.

The great advance as far as the poorer travellers were concerned came in 1872, when the Midland Railway announced that they would carry third-class passengers on all trains: not just on slow, stopping trains, but on the expresses which had previously been the carefully guarded preserve of the wealthy. Other companies cried out in horror, but the Midland quickly increased their share of the traffic. Soon privilege fell to the demands of profitability. The museum has a Midland six-wheeled composite coach of the 1880s which with its first- and third-class compartments set the standard for many years to come. Other refinements followed: sleepers, diners, Pullman coaches and more, but it was the spread of the third class that made the greatest difference to rail travel in Victorian Britain.

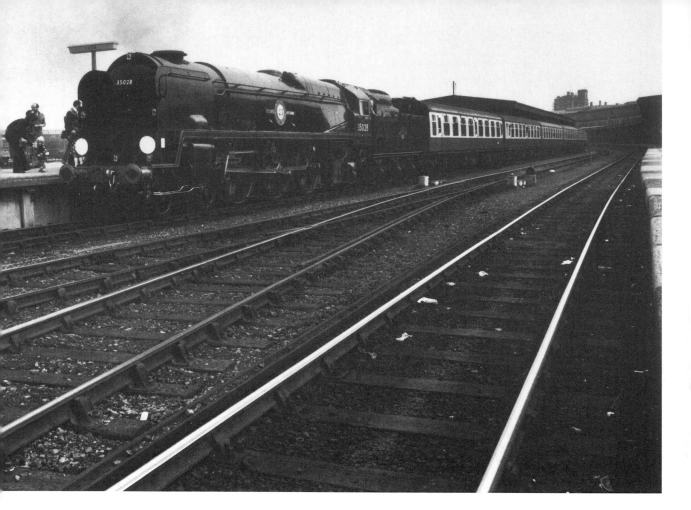

The museum at York is not simply a home for dead engines, a kind of railway mausoleum. Locomotives can be and are taken out of the building, put back into steam and sent out to do a job of work. In the summer of 1978, British Railways took two of the museum's locomotives, *Evening Star* and *Green Arrow*, and put them back into a special week-end service heading trains on a circular route from York, through Leeds, Harrogate and Knaresborough and back to York again. Since then, other locomotives have helped out with the service, and we chose to follow the Merchant Navy Class engine *Clan Line*. This is not, in fact, a museum engine, but another representative of the same class, *Ellerman Lines*, is on display, and is a most popular exhibit. It has been opened up, much in the way that an anatomy lecturer might open up a corpse, to display its innards. This is a particularly interesting class. It was designed by the Southern Railway engineer, Bulleid, and the first examples appeared in 1941. This is not a period one normally associates with railway experiments – build fast and build simple were the rules of the day. Bulleid, however, went in for a very unconventional design, housed in a streamlined cowling. The streamlining later disappeared, and *Clan Line* is in fact one of the third versions of the Merchant Navy class, and was built in 1948. It is a big locomotive, designed for express passenger service, with a 4–6–2 wheel arrangement. Even today, these engines

The Merchant Navy class locomotive, 'Clan Line', heading a steam special waiting to start its run out of York Station.

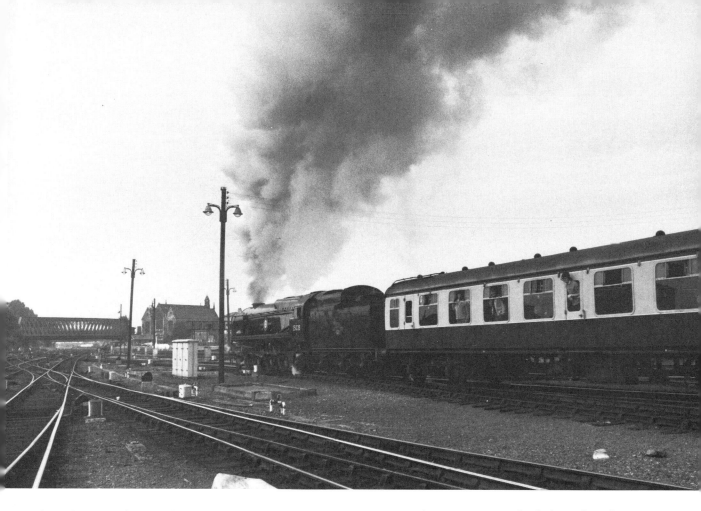

Steaming away from York.

arouse controversy among enthusiasts: some find them handsome, some find them ugly, but no one has ever declared them dull.

The working day for a locomotive begins early in the morning. Getting up steam is a lengthy process, and the fireman's job a skilled one. The fire has to be built up to the correct level; adding the coal a little at a time so that the whole firebox is in use. The fire has to be right at the start of the run or it will never be right once the train is under way. The smoke from the chimney is an indicator of how efficiently a locomotive is being fired. Too much black smoke indicates that the coal is not being properly burned: no smoke at all and too much air is getting into the fire, and valuable heat is being wasted on warming air instead of the water in the boiler.

From the museum yard, the train is made up and run into York station to collect its passengers. At its simplest, a railway station is simply a set of offices and a platform to help passengers reach the high coaches. A cover over the platform provides a little welcome comfort. But the railway station had another role to play in a world of competing companies: it was an advertisement for the companies' wares. The variety of British railway stations is almost as great as the variety of locomotives. There are small stations, rather like country houses, designed to reassure nervous passengers. There are stations in every known architectural style from severe classicism to the most

elaborate Gothic. There are also the great termini designed to im-
press, and grandest of these were the termini in the capital, again
covering the whole range from the flamboyance of the Midland's St
Pancras to the practical simplicity of the Great Northern's King's
Cross. York station is grand rather than grandiose, impressing by its
size and functional simplicity rather than by added decoration.

The route takes in examples of many of the different civil
engineering features to be found on the railway system. The first
stage, from York to Leeds, seems to offer few railway spectaculars;
not surprisingly, perhaps, since it runs across the level countryside of
the Vale of York. Even so, there are a number of quite deep cuttings,
which represent considerable civil engineering achievements. A good
example is the rock cutting near Peckfield Colliery, which with its
multiplicity of sidings is yet another reminder of the continuing con-
nection between coal mines and the railways. Marsh Lane cutting
started life as a tunnel, but was considered unsafe and was opened
out in the 1860s.

The stations along the way are mostly small and homely though
Church Fenton, a village twelve miles south of York, can actually
boast three of them and provides a type of fossilised record of the
complexity of Victorian railway changes. The original was built by the
York and North Midland Railway, back in 1840. The buildings were

Crimple viaduct, just outside Harrogate.

attractively designed in fashionable Gothic. Then, in 1854, after only fourteen years of independent existence, it was swallowed up in an amalgamation, and became part of the North Eastern Railway. It was to have some illustrious companions, for in 1863, the NER also absorbed the pioneering Stockton and Darlington Railway. The new company built a new station, replacing the old stone buildings with a new brick complex. As the system grew, so the second station was replaced in turn by the third, the largest of the three. Brick and stone gave way to cast iron, in the form of iron columns and supports and decorative iron seats. Church Fenton, it was confidently stated, would grow with the railways. It never did.

The city of Leeds provides some interesting contrasts. The tracks come in over a viaduct that crosses the Leeds and Liverpool Canal, close to the point where it runs into the River Aire. Looking down on the canal one might well see a boat, almost certainly a pleasure boat, slowly making its way past empty warehouses and the hull of an old working boat half submerged in the water. The Aire, part of the Aire and Calder Navigation, offers a slightly busier scene. Freight traffic is not yet dead here, though it is only a fraction of what it would have been when the railway was new. Memories of the old trade remain in the wharf, close to Leeds station, where cranes and warehouses line the river front. It is tempting to see the process as part of a linear

development: the old decaying to make way for the new. This is by no means the case. The old was too often killed off as a deliberate act of policy because the new needed the trade to ensure a quick return on a very large investment. There were, and are, good arguments in favour of a transport mixture of road, rail and water, but the arguments failed in the face of the clamour raised by sectional interests.

Leeds does offer an interesting insight into the importance given to railway development by Victorian society. The lines pass close to the Parish Church, and to make room for the tracks the graveyard had to be dug up – together with some quite recently buried inmates – and the gravestones were given a new home on the steep side of the railway embankment. The dead as well as the living had to make way for progress.

Leeds is a city built around the cloth trade, and as the train moves out through the suburbs you can see how the city has spread out from the mills that cluster around the centre. Then, on the outskirts of the city, the tracks disappear into the long Bramhope tunnel. The railway tunnels had to be built to far larger dimensions than the canal tunnels, but the actual technique of construction had improved very little. Much of the work still fell to the navvy working with pickaxe and shovel. It was hard work and dangerous. In Otley churchyard, not far from the north end of the tunnel, there is a memorial to those navvies who died while doing the work.

Coming back into the light you emerge through the impressive castellated portal with its accompanying round tower. This tower was the home of the tunnel keeper who was entrusted with the job of supervising traffic movements. You come out to a very different world, one of wide vistas with the long valley of Wharfedale stretching away to the west. This is an area still dotted with sheep farms, and the cottages where wool was spun and woven before mechanisation took the industry into the heart of Leeds. It was a way of life that was already dying when the railway came, and the cheap, fast travel between towns and cities contributed to its end.

Ahead lies Harrogate, a spa town which the railway helped to popularise. A loop was built to take Leeds passengers to the growing holiday centre. A high bank leads up towards the huge Crimple viaduct which crosses a deep rift and the original Leeds to Thirsk line. That has now gone, and only the straight track bed beneath the arches shows where it once ran. Viaduct and embankment are soon followed by cuttings that take the train into Harrogate without the residents of the genteel spa being troubled by the sight of a train above ground level.

Knaresborough, the next town on the tour, can boast two important features. First, the River Nidd is crossed by a viaduct which is far less majestic in scale than Crimple, but altogether more picturesque. The town is dominated by a ruined castle perched on the cliff top

The railway companies saved their best efforts for the great London termini: the vast roof of the train shed at Brunel's Paddington Station.

above the river, so the railway engineers built a viaduct to match the style. It is mock medieval, complete with battlements and arrow slits. For some time, it was fashionable to sneer at such obvious anachronisms, but a quarter of a century's exposure to featureless concrete has made such structures seem less absurd and rather more endearing. Beyond the viaduct is the station and a deep cutting, which was later roofed over to make a 'cut and fill' tunnel. The return to York over Marston Moor offers few remarkable features.

Back at York, the railway enthusiasts tend to congregate, licensing hours permitting, in the bar of the Railway Hotel. The hotel, rather like the station, has an air of worthiness, of somewhat self-satisfied respectability. It is neither grandiose nor humble, but rather proclaims the values of its time. These are the values of the new age of progress, of the emergent middle class. The style is that of the new villas, replete with stained glass and decorative tile, with polished brass and shining mahogany. This is a good place to end a survey of the industrial revolution, with a prosperity that would have seemed as impossible a century before as a trip to the moon would have seemed to the Victorians.

What, then, is the measure of progress? Is it to be seen in terms of the glass chandeliers of the railway hotel or in the navvies' grave in Otley churchyard? The industrial revolution created wealth yet in every industry one finds that someone has had to pay for it: the apprentices in the cotton mill, the miners who died in the new age of deep mining, the grinders whose lungs were choked with metal dust. They say that one of the bottle kilns at Gladstone is haunted by the ghost of a dead fireman. Perhaps so, perhaps not, but every industry is haunted by the memory of suffering. The progress is real but so was the pain. Both are a part of the industrial past in which our industrial present was born.

Above and below
The navvies' grave in Otley churchyard.

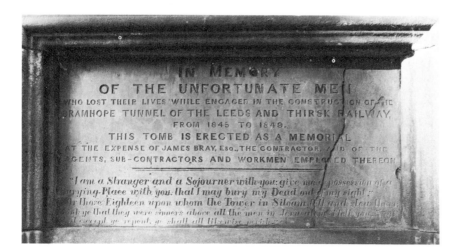

Gazetteer

It is not possible to give a complete gazetteer of industrial sites in Britain, nor even more than a selection of those which are open to the public. The following is a short list of museums which relate specifically to the subjects treated in this book, including all those sites mentioned in the main text.

1 Before the Revolution

Clearwell, Gloucestershire: ancient iron mines.

Dounby, Orkney: horizontal or click mill, off B9057, north of the town.

Haxted, Surrey: Haxted Watermill Museum, based on watermill built c. 1700.

Heckington, Lincolnshire: eight-sailed tower mill of 1830.

Outwood, Surrey: oldest working windmill in Britain.

Priston, Avon: Priston mill, Priston Farm, water-powered corn mill, still in use.

Pumpsaint, Dyfed: Dolaucothi Roman gold mines.

Saxtead Green, Suffolk: eighteenth-century post mill.

Stoke Heath, Bromsgrove, Worcestershire: Avoncroft Museum of Buildings.

Weeting, Norfolk: Grimes Graves, south of the B1108.

2 Steam and the Pit

Beamish, Durham: North of England Open Air Museum.

Brentford, London: Kew Bridge Pumping Station, Kew Bridge Road, seven pumping engines in original pumping house.

Dartmouth, Devon: Newcomen engine in Royal Avenue Gardens.

Great Bedwyn, Wiltshire: Crofton engine house, $1\frac{1}{2}$ miles south-west of village.

Lound, Nottinghamshire: Lound Hall Mining Museum, next to Bevercotes colliery.

Pool, Cornwall: preserved Cornish beam engines on either side of A30.

Tranent, Lothian: Prestongrange steam engine and mining museum.

Tunstall, Staffordshire: Chatterley Whitfield Colliery, Biddulph Road.

3 The New Iron Age

Bonawe, Argyllshire: charcoal furnace on southern side of Loch Etive.

Ironbridge, Shropshire: Coalbrookdale Museum on B4169; Blists Hill Open Air Museum, Coalport Road, Madeley.

Llanberis, Gwynedd: North Wales Quarrying Museum, off A4086.

Loxey, Isle of Man: Lady Isabella 72-foot diameter water wheel.

Redditch, Worcestershire: forge mill, off A441; needle making factory.

Sheffield, Yorkshire: Abbeydale industrial hamlet, Abbeydale Road, nineteenth-century scythe works; Shepherd Wheel, Whiteley Woods, cutlery grinding works.

Singleton, West Sussex: Weald and Downland Open Air Museum, early iron making and forge.

Sticklepath, Devon: Finch's Foundry, beside A30.

4 Spindle and Shuttle
Blackburn, Lancashire: Lewis Museum of Textile Machinery, Exchange Street.

Bolton, Lancashire: Hall i' th' Wood Museum, home of Samuel Crompton; Tonge Moor Textile Museum, Tonge Moor Road.

Bradford, Yorkshire: Industrial Museum, Moorside Mills, Eccleshill, museum housed in former woollen mill.

Dre-fach Felindre, Dyfed: Museum of the Woollen Industry.

Huddersfield, Yorkshire: Colne Valley Museum, Cliffe Ash, Golcar, weavers' cottages.

Kilbarchan, Strathclyde, Renfrewshire: eighteenth-century weaver's cottage.

St Fagan's, South Glamorganshire: Welsh Folk Museum, contains fulling mill.

Styal, Cheshire: Quarry Bank Mill.

Talybont, Dyfed: Lerry tweed mill.

Walkerburn, Borders: Tweedvale Mill, Scottish Museum of Wool.

5 To Make a Teacup
Barlaston, Staffordshire: Wedgwood Museum.

Cheddleton, Staffordshire: Cheddleton flint mill.

Coalport, Shropshire: Coalport China Works Museum.

St Austell, Cornwall: Wheal Martyn Museum, on A391, two miles north of town.

Stoke-on-Trent, Staffordshire: Gladstone Pottery Museum, Uttoxeter Road, Longton.

6 The Venice of England
Dudley, West Midlands: Black Country Museum, Tipton Road.

Ellesmere Port, Cheshire: Boat Museum, at junction of Shropshire Union and Manchester Ship Canal.

Morwellham, Devon: harbour with canal and inclined plane.

Stoke Bruerne, Northamptonshire: Waterways Museum.

7 Steam on the Move
Bristol, Avon: SS Great Britain, Cumberland Road dock.

Exeter, Devon: Maritime Museum, town quay and canal basin.

Great Yarmouth, Norfolk: Steam drifter, *Lydia Eve*, moored at South Quay.

Leeds, Yorkshire: Middleton Colliery Railway, Garnet Road.
Middleton, Derbyshire: Middleton Top engine house.
Shildon, Durham: Timothy Hackworth Museum and engine shed.
Windermere, Cumbria: Steamboat museum, Bayrigg Road.

There are numerous steam preservation societies running passenger trips throughout Britain. They are all listed in *Historical Transport*, published annually by the Transport Trust.

8 Railway Mania
Carnforth, Lancashire: Steamtown Railway Museum, beside
 Carnforth station.
Darlington, Durham: North Road Station Railway Museum.
Falkirk, Stirlingshire: Scottish Railway Preservation Society,
 Wallace Street.
Sunderland, Tyne and Wear: Monkwearmouth Station Museum,
 North Bridge Street.
York: National Railway Museum, Leeman Road.

Apart from this list there are many steam preservation societies who run their own museums.

Index

A

apprentices, 69, 86, 113
Archimedes, 149
Arkwright, Richard, 10, 81, 82
Astbury, John, 96
Avoncroft Museum of Buildings,
 20–6, 33, 72

B

Beamish, *see* North of England
 Open Air Museum
Benson, Thomas, 96
Bertha, 150–4
Bingley, 116
Birmingham, 115–28
Black Country Museum, 130–4
Blaenavon, 72
Blenkinsop, John, 143–4
Boulton and Watt, 30, 31–6, 138, 140
Bourn mill, 20
Bramhope tunnel, 168, 170
Bridgwater, Duke of, 116, 120
Bridgwater, Somerset, 151
Brindley, James, 101, 120, 121–2, 137
Bristol, 149, 151
Bristol Brass Wire Company, 50
Broseley, 136
Brunel, Isambard Kingdom, 149–54
Bulleid, O. V. S., 164

C

canals
 Aire and Calder, 144, 167
 Birmingham, 115–28
 Birmingham and Fazeley,
 116, 117, 118
 Bridgewater, 10, 116, 120
 Coventry, 28
 Cromford, 136, 137
 Dudley, 128–34
 Ellesmere, 116, 126
 Exeter, 150, 151
 Forth and Clyde, 149
 Huddersfield, 116
 Kennet and Avon, 31–6
 Languedoc, 116
 Leeds and Liverpool, 116, 121, 167
 Mersey and Irwell, 116
 Oxford, 28
 Peak Forest, 136
 Shrewsbury, 126
 Stourbridge, 141
 Worcester and Birmingham,
 116, 117, 125

Carron iron works, 10
Cartwright, Edmund, 93
Champion, Richard, 101
Charlestown, 110
Charlotte Dundas, 149
Chatterley Whitfield colliery, 41–8
Chaucer, Geoffrey, 20
Cheddleton, 95–101
china clay, 101–4, 106–10
Church Fenton, 166
Clowes, Josiah, 126
Coalbrookdale, 52–7, 136, 140
Colne Valley Museum, *see* Golcar
Cook, Thomas, 156
Cookworthy, William, 101
Corliss, George, 42
Cort, Henry, 63
Crimple viaduct, 167, 168
Crofton, 31–6, 51
Cromford, 36, 66, 67,
 see also canals, railways
Crompton, Samuel, 81
Crowther, Phineas, 36–7
Cugnot, Nicolas, 140

D

Danzey Green windmill, 20–6, 33
Darby, Abraham I, 50, 53
Darby, Abraham III, 55–7
Dartmouth, 28, 30
Deloney, Thomas, 77
Dolaucothi, 9, 15–19, 28
Dudley, 29, 30, 127, 130–4,
 see also canals
Dudley and Ward, Lord Vincent, 128

E

Ericsson, John, 149
Exeter Maritime Museum, 150–4

F

Finch's Foundry, 52, 63–8
flint
 mining, 11–14
 grinding, 96–101
flying shuttle, 76, 81, 82

G

Galton Bridge, 126
George III, 31
Gladstone Pottery, 87, 88, 111–14, 170

Golcar, 74–5, 93–4
Great Britain, 149, 150
Great Western, 154
Greg, Samuel, 82, 84, 85, 86, 89, 93
Gresley, Sir Nigel, 162
Grimes Graves, 11–14

H

Hargreaves, James, 10, 81, 82
Harrogate, 168
Hero of Alexandria, 20
Huddersfield, 70, 93–4
Hudson, George, 157
Hughes, John, 79

I

iron
 chain making, 71
 forges, 63–71, 72
 foundries, 52–63
 nail making, 72
Ironbridge, 55–7, 72

J

Jessop, William, 126
Jouffroy d'Abbons, Marquis, 149

K

kaolin, *see* china clay
Kay, John, 76, 81, 82
Knaresborough, 155, 168, 169

L

Leeds, 167–8
Leonardo da Vinci, 76, 119
Lerry tweed mill, 77–9
Llanberis, *see* North Wales
 Quarrying Museum
locomotives
 Agenoria, 158
 Clan Line, 155, 164–7
 Ellerman Lines, 164
 Evening Star, 158, 161, 164
 Green Arrow, 164
 Hardwicke, 161
 Locomotion, 135, 143, 144–5, 159
 Mallard, 162
 Peckett, 145–6
 Prince Regent, 144
 Rocket, 145, 146, 148

Salamanca, 144
Stirling Single, 158, 160
Trevithick, 140
Windle, 147
looms
 hand, 74–6, 79, 80
 power, 93
Loxey, 60

M
Meissen, 101
Merthyr Tydfil, 72
Middleton engine house,
 see steam engines
mines
 coal, 27, 28, 34, 36–48
 flint, 11–14
 gold, 9, 15–19, 28
Murdock, William, 140
Murray, Matthew, 143–4, 145

N
National Railway Museum, *see* York
Newbury, 77
Newcomen, Thomas, 28, 31
Nicholas, Czar, 144
North of England Open Air Museum,
 28–31, 34, 36–41, 135, 143, 144–5
North Wales Quarrying Museum,
 49, 58–62

O
Oldknow, Samuel, 136
Onions, Peter, 63
Otley, 168, 170

P
Penydarren, 140
Pettit Smith, Francis, 149
pottery
 manufacture, 105, 110–14
 raw materials, 95–104, 106–10
Pumpsaint, *see* Dolaucothi
Pyroscaphe, 149

Q
Quarry Bank Mill, *see* Styal

R
railways
 Bodmin and Wadebridge, 163
 Cromford and High Peak,
 136–9, 142, 145
 Great Northern, 156, 158, 166
 Great Western, 154, 158, 169
 Liverpool and Manchester, 145–6
 London and North Eastern, 162
 London and North Western, 156, 161
 Middleton, 143–4, 145–8, 160
 Midland, 157, 163, 166
 North Eastern, 167
 Penydarren, 140
 Southern, 164
 Stockton and Darlington, 144–5
 York and North Midland, 157, 166–7
Rainhill, 145, 146, 149
Runcorn, 120

S
St Austell, 102–3
Savery, Captain Thomas, 28, 30
Severn, 53–4, 57, 58
Sèvres, 101
slate quarries, 58–62
spinning jenny, 10, 81, 82
Standedge, 116
steam engines
 Beamish, 36–7
 Chatterley Whitfield, 42
 Cheddleton, 100
 Crofton, 31–6, 51
 Dartmouth, 28–31
 Exeter, 69–71
 Gladstone, 111
 Ironbridge, 72
 Middleton Top, 137–9, 142
 Styal, 91
 see also locomotives
Stephenson, George, 144–5, 146, 148
Stephenson, Robert, 146, 148
Sticklepath, *see* Finch's Foundry
Stirling, Patrick, 158, 160
Styal, 69, 82–6, 89–93
Symington, William, 149

T
Talybont, *see* Lerry mill
Tardebigge, 116
Telford, Thomas, 122, 123, 125–6
textiles
 cotton, 80–6, 89–93

wool, 74–80, 93–4
Trevithick, Richard, 57, 140, 143, 156

W
water power
 Cheddleton, 43–4, 97–8, 99
 Coalbrookdale, 54
 Finch's Foundry, 63–8
 Llanberis, 49, 59, 60
 Loxey, 60
 Styal, 82, 84
 Talybont, 79
 Wheal Martyn, 102, 103, 107–9
Watt, James, 31
 see also Boulton and Watt
Wedgwood, Josiah, 10, 111
Whaley Bridge, 136
Wheal Martyn, 101–4, 106–10
Wilkinson, John, 35
Williamson, Hugh Henshall, 41
wind power, 19–26, 33
Wollaton, 136

Y
York
 hotel, 169
 National Railway Museum,
 157–8, 160–4
 station, 164, 166